The Campus History Series

UNIVERSITY OF MEMPHIS

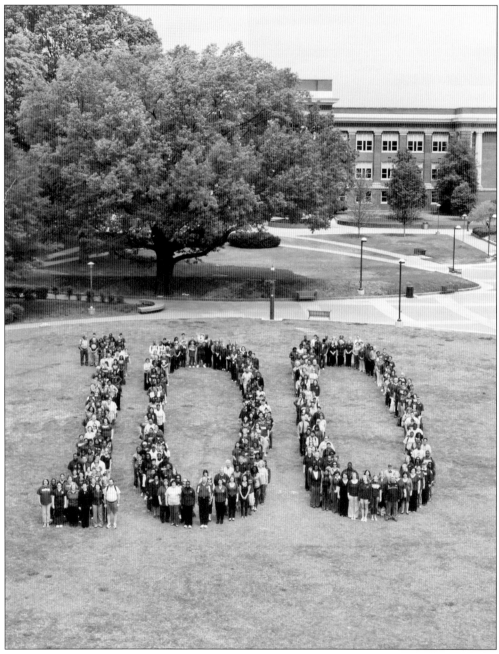

In this photograph, students, staff, faculty, and administrators put their bodies on the line in support of the university's centennial celebration. (Courtesy of the Offices of Development and Communication Services, University of Memphis.)

ON THE COVER: This 1960s-era varsity cheering squad demonstrates the team spirit and gymnastic prowess that have earned University of Memphis cheerleaders recognition as one of the "Premier College Squads in the Nation." (Courtesy of the University of Memphis Libraries.)

The Campus History Series

UNIVERSITY OF MEMPHIS

BEVERLY BOND AND JANANN SHERMAN
WITH FRANCES WRIGHT BRELAND

Copyright © 2012 by Beverly Bond and Janann Sherman with Frances Wright Breland
ISBN 978-0-7385-9112-4

Published by Arcadia Publishing
Charleston, South Carolina

Printed in the United States of America

Library of Congress Catalog Card Number: 2011933821

For all general information, please contact Arcadia Publishing:
Telephone 843-853-2070
Fax 843-853-0044
E-mail sales@arcadiapublishing.com
For customer service and orders:
Toll-Free 1-888-313-2665

Visit us on the Internet at www.arcadiapublishing.com

To Dr. Shirley C. Raines, the University of Memphis's number-one "Dreamer, Thinker, Doer," and to Tigers everywhere.

CONTENTS

Acknowledgments		6
Introduction		7
1.	West Tennessee Normal School: 1912 to 1925	11
2.	West Tennessee State Teachers College: 1925 to 1941	35
3.	Memphis State College: 1941 to 1957	59
4.	Memphis State University: 1957 to 1994	83
5.	University of Memphis: 1994 to the Present	109

ACKNOWLEDGMENTS

We are grateful to the following individuals and institutions for their invaluable assistance in helping us locate information and images: Ed Frank and Brigitte Billeaudeaux of Special Collections at the University of Memphis libraries, the Offices of Development and Communication Services, and Rosemary Nelms at the Commercial Appeal.

We would also like to acknowledge the support of our colleagues, friends, and families who have encouraged us in this venture and have been exceedingly patient with our enthusiasm for the history of this great metropolitan university.

Unless otherwise noted, all images appear courtesy of the University of Memphis libraries.

INTRODUCTION

In its 100-year history, the University of Memphis has changed names and missions five times. In 1912, West Tennessee Normal School opened with a mission to provide high school education and teacher training to students and teachers in Tennessee's western counties. Thirteen years later, the school expanded its collegiate offerings and dropped its high school classes to become the West Tennessee State Teachers College (WTSTC). In 1941, WTSTC became a full liberal arts institution called Memphis State College (MSC). With the acquisition of university status in 1957, the college became Memphis State University (MSU). That designation held until 1957, when Memphis State University became the University of Memphis, a name change to reflect its status as a major metropolitan research university.

Well before the establishment of the normal school, educators and civic leaders endorsed the need to build a great university in the area. When the General Education Bill of 1909 provided for the creation of three normal schools in the state, Memphis and Shelby County governments acquired the site and raised sufficient funds to convince the state to locate the West Tennessee Normal School here. Seymour A. Mynders was chosen as the school's first president. He supervised construction, selected the faculty, and prepared the curriculum. The West Tennessee Normal School was officially dedicated on September 10, 1912, with 330 students in residence. Education was free to all white Tennessee residents who were at least 16 years of age, had completed elementary school, and could provide evidence of good moral character and physical health. Room and board cost approximately $40 a month. When President Mynders died in 1913, he was replaced by John Willard Brister. By its second year, the curriculum at WTNS had expanded to 16 departments. Dr. Andrew Kincannon took over the presidency in 1918 and expanded the school's agriculture program. Like the presidents before him, Kincannon was eager to expand beyond the school's original mandate for teacher training. However, he lost the confidence of the State Board of Education (SBE) and was not reappointed in 1924. Dr. Brister returned to the presidency. One year later, the institution discontinued its high school curriculum and was renamed West Tennessee State Teachers College.

College sports teams wore the letter *T* on their uniforms and were called the "Teachers." Among their fans, the *T* came to stand for Tigers. To cement that change, the new student newspaper was called *The Tiger Rag* when it was first published in 1931. The Tiger was officially designated the team mascot in 1939.

The Great Depression was a crisis of international proportions, and at the college, it translated into a struggle for survival. When, twice, the state proposed to close all of its teachers' colleges, only Brister's efforts and a passionate student-led campaign kept it open, but operating funds were severely cut. In September 1939, President Brister died suddenly and Richard C. Jones became the fifth president. The Teachers College offered all subjects necessary for a liberal arts curriculum, and it became Memphis State College in 1941.

After the attack on Pearl Harbor that December, student organizations disbanded as the majority of male students enlisted in the military and female students took on war work. Enrollment for the 1942–1943 school year dropped to 990, the lowest number since

the third year of the normal school, despite the increasing military presence on campus. These federally funded programs were jeopardized when President Jones, citing budgetary constraints, fired two tenured professors in the English Department. The college lost its accreditation, and the military declared that Memphis State was no longer suitable for their programs. Jones tendered his resignation in July 1943. The next president, Dr. Jennings Bryan Sanders, took office, pledging to restore full accreditation and working relationships with the Army and Navy. Sanders accomplished his goals in three years and resigned at the end of June 1946. When the war ended, veterans, granted access to free education under the GI Bill of Rights, flooded into Memphis State College. Thirty new professors were hired as 1946 enrollment topped 3,000 students after bottoming out at 560 in 1944. In August 1946, James Millard "Jack" Smith became the sixth president. A graduate program in education started in 1949. An Air Force Reserve Officer Training Corps (AFROTC) unit was established on the campus in 1951. AFROTC was compulsory for males in their freshman and sophomore years until students voted overwhelmingly to change it to a voluntary service in 1971.

In 1954, the Supreme Court's decision to end segregation in public schools eventually changed campus culture, but not without considerable resistance. Within a month of the decision, five black students applied for admission to Memphis State College, beginning a five-year battle that would be fought in state and federal courts. President Smith proposed a five-year plan for integration, which was approved by the SBE but overturned by the Sixth Circuit Court of Appeals in January 1957. All state universities were ordered to be integrated for the following academic year. After eight African American high school graduates attempted to enroll at Memphis State in the fall of 1958, Smith petitioned for a one-year delay. In September 1959, the "Memphis State Eight" joined the 4,500 white students on campus. Unlike situations at other southern colleges and universities, the black students were not met with violence; instead they were ignored and isolated.

In January 1957, the governor signed legislation re-designating the college as Memphis State University. Smith left the university in December 1959. His successor, Dr. Cecil C. Humphreys, had been associated with the school since joining the history faculty in 1937. Under President Humphreys, MSU experienced an astonishing 260 percent increase in enrollment, from less than 5,000 students in 1960 to nearly 18,000 by the end of the decade. Full-time faculty increased from 200 to 725. Forced to expand the campus to accommodate so many students, the university acquired 314 individual parcels of land adjacent to the campus. The university's largest land acquisition did not cost a cent. A coordinated effort between MSU and the Tennessee congressional delegation resulted in the conveyance of the old Kennedy Army Hospital and 146 acres of land less than a mile southeast of the main campus. This property became South Campus, site of a modern sports complex and married student apartments.

Between 1960 and 1972, the number of buildings increased from 20 to 176. Humphreys also envisioned a pedestrian-friendly campus. In addition to the large front lawn south of the Administration Building, plans called for a gradual restriction of campus parking to the periphery to make the campus safer, calmer, and more beautiful. The first phase converted State Street to a mall on the east side of Brister Tower in 1971. The scale, materials, and layout of the pedestrian plaza set the tone and design for more such areas around campus over the next few decades.

Memphis State's men's sports programs were very successful, with large fan bases that taxed the university's facilities. Memphis and Shelby County governments cooperated in financing the Mid-South Coliseum for Tiger basketball and Memphis Memorial Stadium for football, later renamed Liberty Bowl Memorial Stadium. These facilities hosted all-white teams until 1966, when basketball and football were integrated. Women's intercollegiate sports, which had been suspended in 1938, made a comeback in 1972 after the passage of Title IX, mandating equal treatment in any educational program or activity receiving federal

financial assistance. Although MSU had an official mascot in the tiger since 1939, there was no actual representation of the namesake until a dedicated student created his own Tiger costume in 1960, and Pouncer was born. Twelve years later, the booster club, known as the Highland Hundred, acquired the first live tiger mascot, TOM.

Memphis State University did not escape the turmoil that roiled college campuses in the 1960s, although demonstrations here were comparatively fewer and smaller. They were mostly centered around racial issues and the Vietnam War. Humphreys left the university in 1972 to become chancellor of the new Tennessee Board of Regents. Dr. Billy Mac Jones became the university's eighth president. A new student movement aimed at boosting campus spirit and rehabilitating the image of Memphis State arose in 1971. The university had long been saddled with a derogatory nickname—"Tiger High"—that implied a lack of academic rigor and an overemphasis on athletics. Their solution was to eliminate references to tigers and replace them with nautical references to reflect the school's proximity to the Mississippi River. TOM would be retired and replaced by the Steamers. A new student sports booster group called themselves the "Sidewheelers." First to fall was *The Tiger Rag*. Henceforth, the student newspaper was called *The Helmsman*. However, despite student efforts, with the exception of *The Helmsman*, none of the proposed changes were adopted.

After President Jones resigned in 1980, leadership shifted to Dr. Thomas G. Carpenter. While maintaining the university's educational mission, Carpenter articulated a larger vision for the future: a mature Memphis State as a nationally recognized research institution. Under Carpenter, MSU developed six Centers of Excellence: The Center for Applied Psychological Research, the Tennessee Earthquake Information Center, the School of Accountancy, the Center for Research in Communicative Disorders, the Institute for Egyptian Art and Archaeology, and Education Policy. Carpenter retired in 1991 and welcomed V. Lane Rawlins as the 10th president of Memphis State University. Rawlins had another idea about how to ditch the appellation Tiger High: change the name. The university had matured considerably over the past few decades. It now had a cadre of outstanding faculty members from diverse disciplines, sites of cutting-edge research, and 18 Chairs of Excellence and five Centers of Excellence. Yet, it seemed that the public had failed to take note of the progress. A name change would mark the conversion of Memphis State, said Rawlins, "from a respected commuter school to a major urban university firing the economic and cultural engine of the Mid-South." The Tennessee Board of Regents approved the proposal in 1993; the state assembly followed suit. On July 1, 1994, Memphis State officially became the University of Memphis.

In 1995, the University of Memphis had 19,975 students. The student body was approximately 74 percent white and 21 percent black. When President Rawlins resigned in 2000, Dr. Shirley C. Raines was chosen as the 11th president of the University of Memphis and the first woman to hold this position. At her official investiture on April 15, 2002, she stated her priorities: "We believe our future will be forged by investing in people, building productive partnerships with people in the community, and creating interdisciplinary initiatives among our academic programs and people." Dr. Raines assumed the presidency in the first of many fiscal crises during the next decade. Despite these budget woes, President Raines's skill at building partnerships with the business community resulted in major changes in the university's physical and educational environment.

As the university approaches its centennial, it has an enrollment of over 22,000 students and 930 full-time faculty members. It offers bachelor's degrees in more than 50 majors, master's degrees in over 45 subjects, doctoral degrees in 21 disciplines, a specialist degree in education, and a Juris Doctor. The growth of this institution from a small teacher training school to a major metropolitan research university in just 100 years has been a remarkable journey, far exceeding the dreams of those early Memphis visionaries at the beginning of the 20th century.

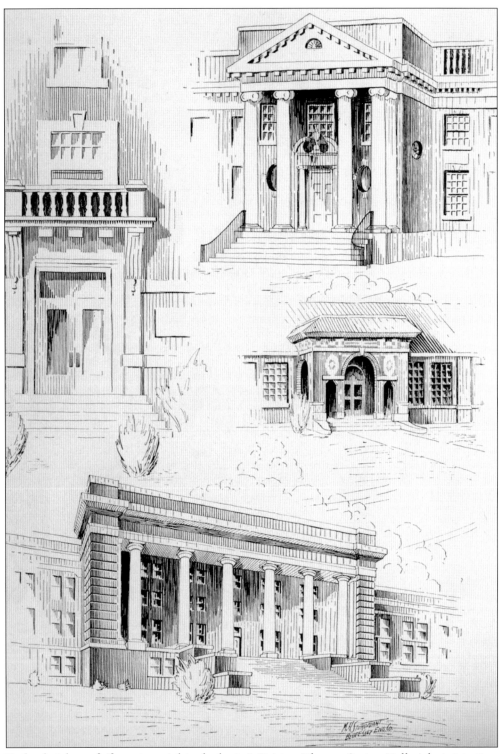

Early sketches of (from top right, clockwise) Brister Library, Scates Hall, Administration Building, and Manning Hall.

One

WEST TENNESSEE NORMAL SCHOOL

1912 TO 1925

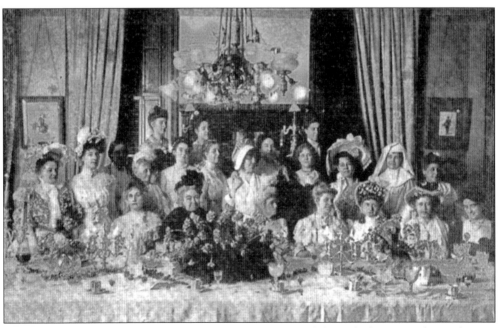

In the early 1900s, members of the city's 19th Century Club, including Dr. Lilian Johnson, attorney Eleanor McCormick, and Shelby County Schools superintendent Mabel C. Williams, along with *Commercial Appeal* editor E.W. Carmack, called for the location of a college in Memphis. Johnson, McCormick, Williams, and local women's clubs raised funds to create the school's endowment.

Tennessee's State Board of Education (SBE) authorized the creation of West Tennessee Normal School (WTNS) in May 1910 after a vigorous fundraising effort organized by Memphis General Campaign brought in $250,000. The school was chartered along with three others under the 1909 General Education Bill. The indication of support from Memphis and Shelby County government and community leaders led the SBE to favor Memphis over several other west Tennessee communities as the site of the region's normal school.

This 1910–1911 proposed layout of the campus suggests that the planners envisioned WTNS as the region's educational anchor.

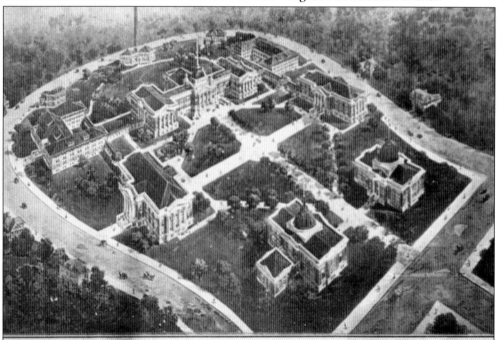

Seymour A. Mynders, the first president of WTNS, oversaw the construction of the school's original buildings, the hiring of the faculty, and the development of the curriculum. Mynders, a former Tennessee superintendent of Public Instruction, with Robert L. Jones and Philander Priestly, also superintendents of Public Instruction; University of Tennessee presidents Brown Ayers and Charles W. Dabney; and public school administrators across the state, including Elizabeth Messick, Mabel C. Williams, and Sidney G. Gilbreath, had advocated for the creation of state normal schools. Mynders's diligence and hard work eventually impacted his health. While recuperating from exhaustion, he died in Ohio on September 17, 1913, at the age of 52.

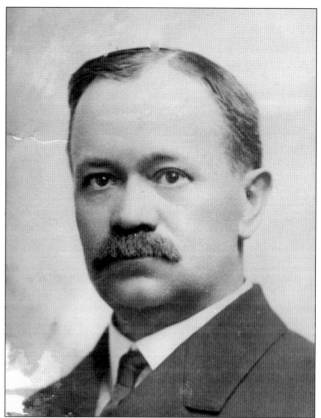

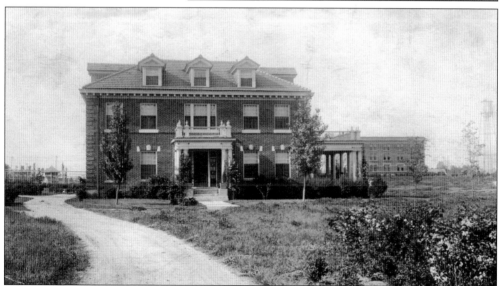

The President's House, pictured above, Mynders Hall (the women's dormitory), and the Administration Building were the three original buildings on campus. Constructed in 1911 and 1912, all three were ready for occupancy when WTNS opened in September 1912. The 135-foot water tower on the right in the photograph was filled with water from a 400-foot-deep artesian well.

Pobricita Richerson "Mother" Mynders came to Memphis with her husband in 1911. Unfortunately, her first few years in the city were marked by the deaths of her daughter Elizabeth and her husband. She remained with the WTNS after President Mynders's death, serving as the faculty sponsor of the Seymour Mynders Fraternity and its sister organization, Sigma Alpha Mu.

Elizabeth Mynders Fritts, daughter of Seymour and Pobricita Mynders, died in January 1912, four months after her marriage to Fred Fritts. The first women's dorm on campus was named in her honor. Fritts's portrait is displayed in Mynders Hall. Campus legend has it that her ghost haunts the building.

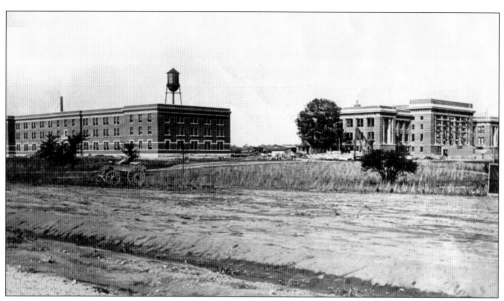

West Tennessee Normal School opened to the first students on September 10, 1912. The institution was chartered, along with three other institutions, under the 1909 General Education Bill to respond to the need for qualified teachers. WTNS was situated on an 80-acre site adjacent to the Southern Railway (the old Memphis & Charleston Railroad). This photograph shows the Administration Building and Mynders Hall, with the water tower in the background.

In the early 1900s, the State Board of Education required that elementary school teachers in Tennessee have a sixth-grade education. In 1910, the board raised the requirement for teachers to a high school diploma and a teaching certificate. The creation of Tennessee's regional normal schools under the 1909 General Education Bill enabled public school teachers to complete these requirements. In the first 40 years of its existence as the West Tennessee Normal School and West Tennessee State Teachers College, the institution primarily added courses and departments to meet the increasing requirements for teacher training throughout the state.

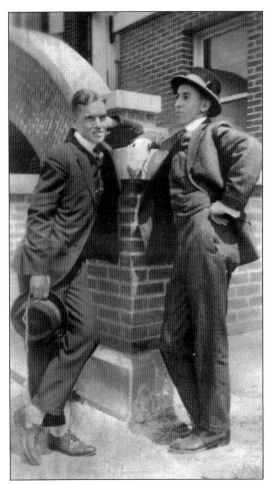

Earnest Ball (left) and Julian Jones were members of the 1915 WTNS senior class. Ball later served as superintendent of Memphis city schools. E.C. Ball Hall, constructed in 1964 to house the Department of Education, was named in his honor.

Members of sports teams like this 1915–1916 men's track team were referred to as the "Normals" or "Normalites" and wore the letter *N* on their uniforms. They competed against local teams, including those from Memphis High School, Memphis University School, and Christian Brothers College.

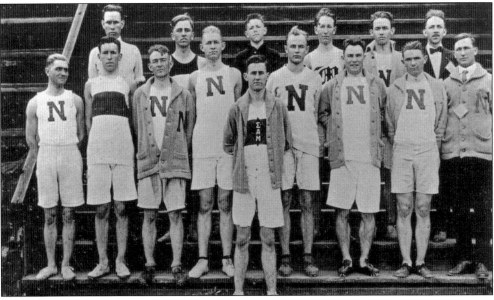

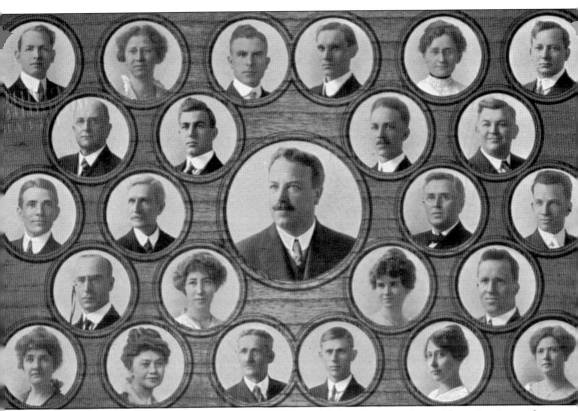

John Willard Brister, West Tennessee State Normal School's second president, is pictured in the center of this photograph with the 1916–1917 faculty. He was appointed president when Seymour Mynders died unexpectedly in 1913. Brister received his MA degree from Peabody College in 1893 and began his college teaching career as a mathematics instructor at that institution in 1902. Brister worked with Seymour Mynders and other supporters in the campaign to improve public education in Tennessee. In 1911, he was appointed state superintendent of Public Instruction. This proved to be a short appointment, and two years later he was appointed to the presidency of WTNS. The 24 faculty members held degrees from some of the nation's leading institutions, including Columbia, Harvard, Yale, the University of Chicago, Vassar, Vanderbilt, George Peabody, and the University of Tennessee. WTNS offered four years of high school and two years of teacher training, including courses in education, mathematics, history, English, Latin, home economics, manual training, drawing and writing, public speaking, and music.

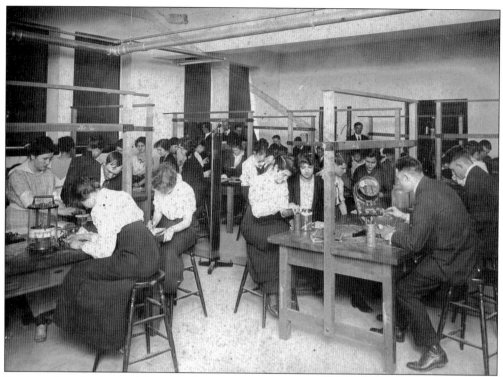
Students in this physics lab study electricity and the properties of circuits.

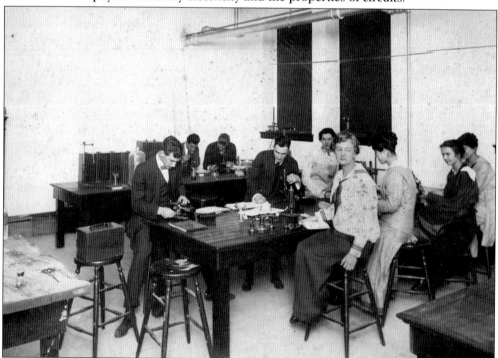
From 1912 until the construction of Manning Hall in 1930, all classes, including this chemistry lab, met in the Administration Building.

Pictured on the right are members of the freshman class in the teacher certification program. Their class motto was *facto non verbo* ("by deed, not word"). They chose royal purple and gold for their class colors and the violet for their flower.

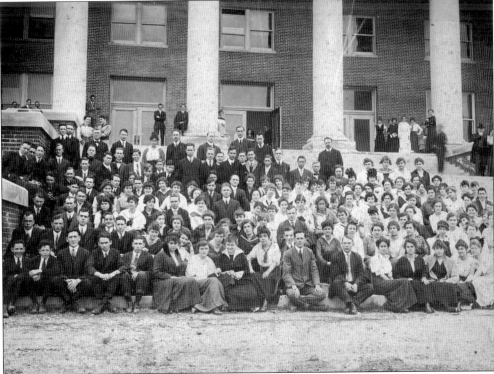

WTNS provided classes for public-school teachers from counties in West Tennessee. While the school offered regular enrollment in the fall and spring semesters, the summer term typically had the largest numbers of students. Most summer school students were already employed as elementary schoolteachers during the regular terms and took courses for teacher certification during the summer months.

Groups of students frequently posed for formal photographs on the imposing 100-step entrance to the Administration Building.

Since the school's exclusive function was to train teachers for public school service, most of the early graduates were women. Students were required to sign a pledge that they would teach in public schools for at least as many years as they had received state-funded education at the normal school. The Tennessee Assembly eliminated the pledge in the fall of 1939, shortly before the school became a four-year liberal arts college.

The first issue of the WTNS yearbook, the *DeSoto*, was released in 1916. The yearbook was named in honor of local judge Walter Malone's epic poem, "DeSoto." The editor-in-chief was senior Signa Crichfield, pictured in the center left of the above photograph.

Student members of county clubs surveyed their West Tennessee communities to learn what their neighbors felt should be offered at the WTNS. This strategy encouraged strong relationships between educators in the counties and the normal school's students and faculty. In 1914, President Brister led the effort to reorganize the West Tennessee Teachers Association and brought the organization to the campus for its convention. The Teachers Association presented the portrait of Seymour Mynders, which hangs in the rotunda of the Administration Building.

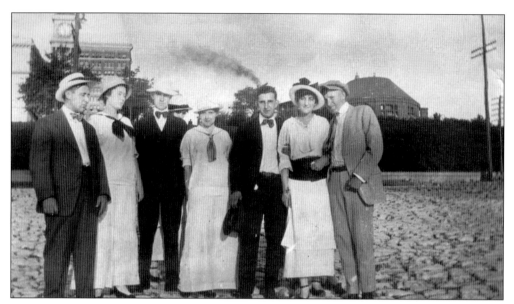

During summer sessions, students took the trolley from the Normal Station downtown for picnics or shopping. Female students were forbidden to go off campus, or even to the remote areas of the campus, without chaperones.

History professor Hubert Dennison (wearing a hat) socializes with his students between classes.

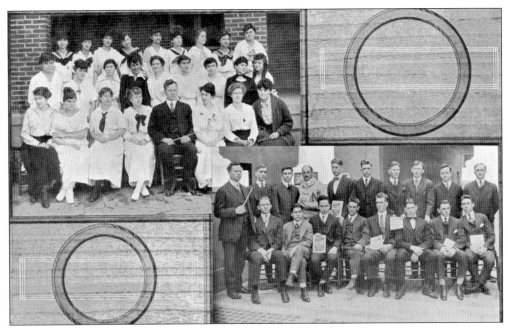

The Girls' Glee Club (top left) and the Men's Chorus (bottom right) are pictured in this 1916 photograph. The groups frequently performed for campus functions.

WTNS's first Student Government Association was established in 1917. It was an all-female council since the association's job was to police the behavior of the female students in Mynders Hall. Before the SGA was established, faculty members dealt with rule infractions by keeping female students after chapel.

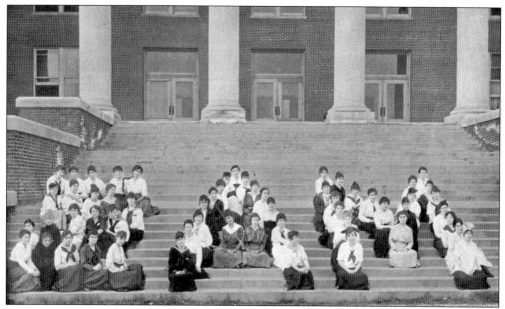

Founded in 1912, Sigma Alpha Mu was one of the three original campus social clubs and the first exclusively for women. The sorority's initials replicated those of Pres. Seymour A. Mynders. The women of Sigma Alpha Mu sorority are pictured on the steps of the Administration Building in this 1917 photograph.

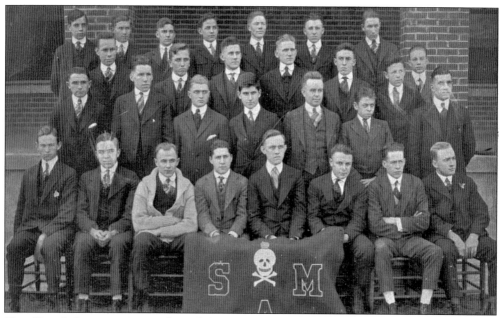

The all-male Seymour A. Mynders Club, informally known as Mynders Boys, was organized in 1914 to honor the first WTNS president. The club's motto, *Nil Nissi Bonum*, translates as "Speak no evil."

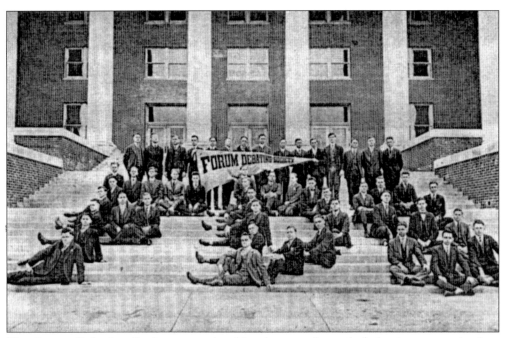

The Forum Debating Society, seen in this photograph, and their sister organization, Kappa Lambda Sigma, were originally part of the Claxtonian Literary Society. The latter organization was named for Priestly Philander Claxton, who had spearheaded the campaign to create the state's normal schools. The Forum Debating Society became Phi Lambda Delta in the early 1920s.

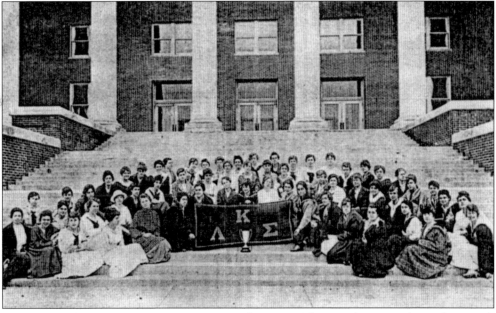

Kappa Lambda Sigma Sorority was organized in 1913. The members are shown here with the Debate Tournament trophy that they received in 1917 for excellence in competition with the other three campus social clubs. Their sorority yell was "Rah, rah, rega! Kappa Lambda Sigma! Hip, hurrah, hip, hurrah! Three cheers for Kappa Lambdas, rah, rah, rah!"

Andrew Kincannon became WTNS's third president when the SBE elected not to reappoint John Willard Brister in 1918. Before coming to Memphis, Kincannon served as the state superintendent of education in Mississippi, president of Industrial Institute and College (now Mississippi University for Women), chancellor of the University of Mississippi, and superintendent of Memphis City Schools for four years. Kincannon expanded WTNS's agriculture program and had a swimming pool constructed east of the Administration Building by lining a gully with sand and filling it with water to use as a pool. It collapsed three summers later.

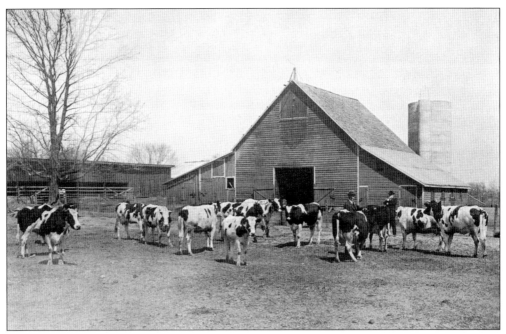

WTNS acquired a herd of Holstein dairy cows and a newfangled milking machine, a herd of registered duroc pigs, and a colony of rabbits for a demonstration project. The school also added a poultry yard and nesting house on the north side of campus, as well as a series of demonstration plats and gardens.

Relaxing on a pile at the end of a hard day, these students take advantage of the campus's serene pastoral setting.

One year into World War I, the US Army announced that WTNS was eligible to host a Students' Army Training Corps to train possible candidates for Officer Candidate Schools. More than 300 men applied, and 238 were accepted into the SATC.

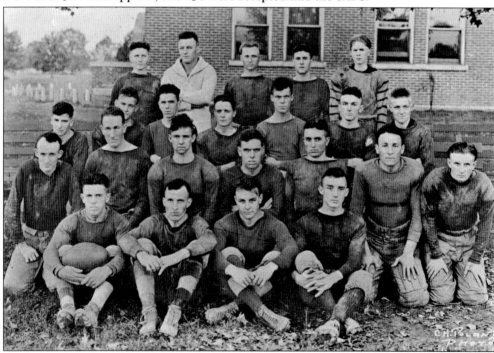

The football team played one of its earliest games against Memphis High School, later called Central High, in 1913. Other competitors included Memphis University School, Christian Brothers College, and Whitehaven High School. The 1918–1919 team is pictured in this photograph.

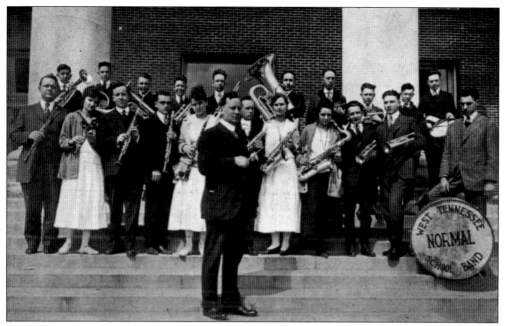

L.C. Austin and the West Tennessee Normal School Orchestra pose in the main hall of the Administration Building in this 1919 photograph. Austin's wife taught voice lessons and was the accompanist for all the musical groups on campus.

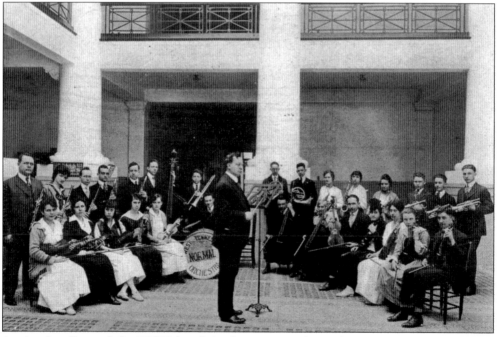

Austin also directed the WTNS band. Both groups performed at campus and community functions. School activities like these musical performances highlighted the strengths of the faculty and students and drew residents from the surrounding neighborhoods to the campus. Like other campus groups, these photographs of the orchestra and the band were taken on or near the Administration Building's imposing steps and columns.

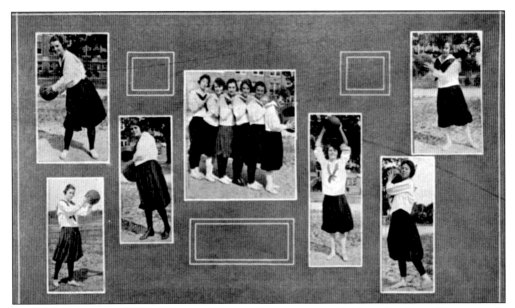

Women's basketball teams, like this 1921–1922 WTNS squad, played a three-division style of game. The court was divided into three areas, with nine players per team. Three players (guard, center, and forward) were assigned to each area and could not cross the line into another area. The ball was moved from section to section by passing or dribbling. Players were limited to three dribbles and could hold the ball for only three seconds.

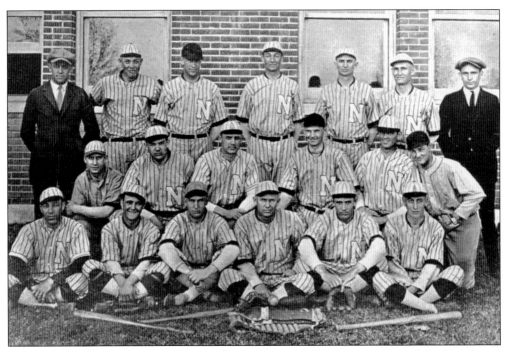

WTNS chose blue and gray as its school colors to symbolize the reunion of the North and South after the Civil War, but the school had no official mascot until the tiger was chosen in 1939. The 1922–1923 men's baseball team is pictured in this photograph.

For the first 10 years of the school's existence, students who lived on campus dined in a first-floor section of Mynders Hall. Constructed in 1922, Jones Hall, the school's first cafeteria, was a center for student socializing and activity.

The cafeteria served three meals a day, except on Sundays, when it served a large lunch slightly later than usual to accommodate students who attended neighborhood churches. A bag supper was substituted for dinner so that the staff, many of whom were student workers, could have the evening off.

Constructed in 1923, Scates Hall served as the first men's dormitory on campus. Prior to its construction, male students lived on the fourth floor of the Administration Building, with local families, or in the Prescott Flats apartments at the corner of Southern and Walker Avenues.

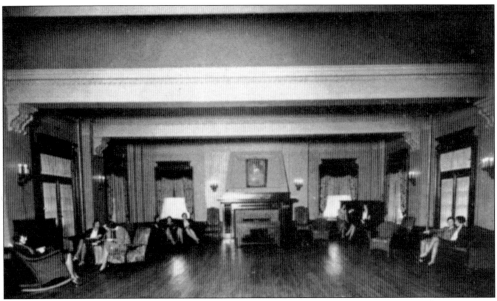

Although men were housed in Mynders Hall during World War II, their movements were strictly monitored by dormitory matron and dean of women, Nellie Angel Smith. An alumna from the late 1930s remembered Smith's instruction to female students that "there was an imaginary line about 50 feet from Mynders Hall that no male students should cross."

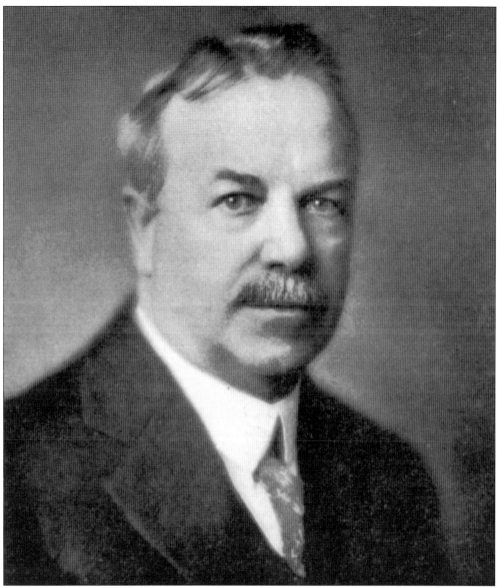

John W. Brister returned to the presidency of WTNS in 1924 to replace Kincannon. As the longest serving president with his two combined terms and devoting nearly 20 years to the institution, Brister left an imposing footprint on the institution's formative years. He oversaw the expansion of the curriculum and construction of new buildings. Brister died suddenly in 1939 of an unspecified illness, likely brought on by the intense financial difficulties of the 1930s, when the state ran out of money and twice tried to close the teachers' colleges.

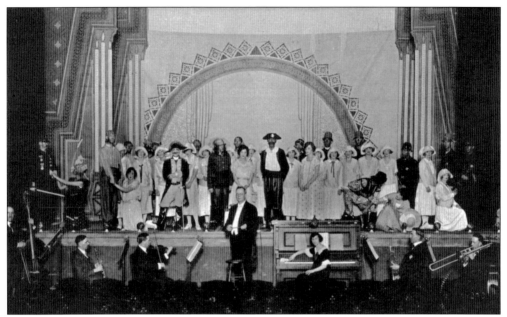

Despite the school's major function as a teacher training institution, its location was not particularly close to Memphis's traditional musical venues. The plays and musicals performed by campus groups provided entertainment for WTNS students and residents of the surrounding community of Normal Station. This photograph shows the cast and orchestra for the April 1924 production of *The Pirates of Penzance*.

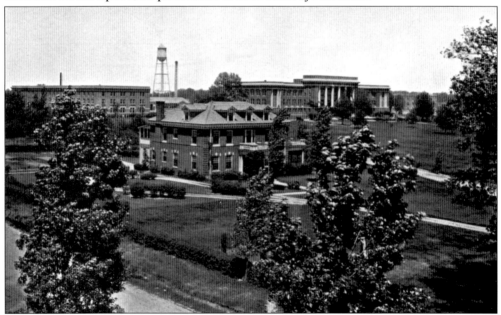

Campus facilities and the student body had grown by 1925, when West Tennessee Normal School became West Tennessee State Teachers College (WTSTC). High school classes were eliminated, the majority of the student body attended the regular terms instead of the summer, and the institution now awarded a bachelor's degree. A dining hall and men's dormitory were added to the three original campus buildings.

Two

West Tennessee State Teachers College

1925 to 1941

Course offerings at West Tennessee State Teachers College reflected changing standards for teacher certification in Tennessee, as well as a push from President Brister to broaden the school's curriculum and create a more regional identity. Students wore only "STC," and athletes wore the letter *T* on their uniforms instead of *N* and were known as the "Teachers" or "Tutors" instead of the "Normals" or "Normalites."

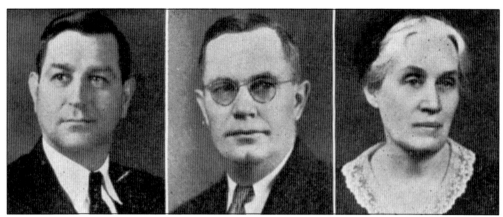

One of the most significant traditions in the institution's early years was the long tenure of many of its pioneering educators. J. Millard Smith (above, left) came in 1927 to oversee the men's dormitory and held various administrative positions over the next few decades before becoming president of the institution in 1946. Otis H. Jones (above, center) taught in Shelby County before serving as Bursar at Memphis State College from 1925 to 1937 and as chief financial officer for the Board of Education. He later authored an unpublished manuscript on the school's first 50 years. Nellie Angel Smith (above, right) served as professor of Latin, head of the Department of Languages, and from 1927 to 1947 was the first dean of women. She retired in 1952. Flora Rawls (below) joined the faculty in 1930 and served as a teacher and administrator at the college and the training school before her tenure as dean of women from 1947 to 1970. J. Millard Smith Hall, Otis H. Jones Hall, Nellie Angel Smith Hall, and Flora Rawls Hall were named for these pioneering educators.

The school's alma mater, written by Pres. John W. Brister, was first performed at the spring graduation in May 1927. Sung to the tune of an old Methodist hymn, "Lead on O King Eternal," Brister's composition remains an important part of campus events, from opening convocations to graduation ceremonies.

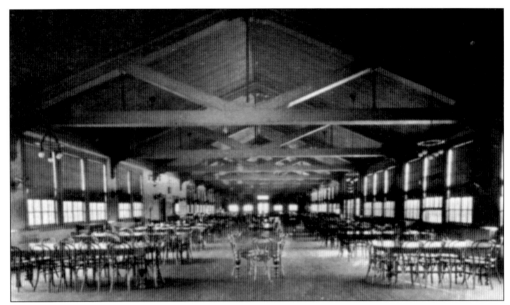

In order to minimize state expenditures for WTSTC, Presidents Kincannon and Brister tried to make the school more self-sustaining. The school kept a herd of dairy cattle and chickens. The livestock functioned as teaching tools for the agriculture department and produced milk, cheese, and eggs to feed students dining in Jones Hall (shown above).

Until the mid-1920s, WTSTC had its own electricity plant and water tower. Water drawn from a nearby artesian well was pumped into the campus's water tower and dispensed to campus facilities, as well as to residences and businesses in the neighborhood. In 1929, Memphis extended its boundaries to Goodlett Avenue and began providing water and fire and police services for the area.

Physical education was an important part of campus life. The Memorial Gymnasium, pictured in this photograph, was constructed in 1927. Before this, the girls' and boys' basketball teams practiced in a large room on the second floor of the Administration Building. Interscholastic games were played at the neighboring YMCA gym.

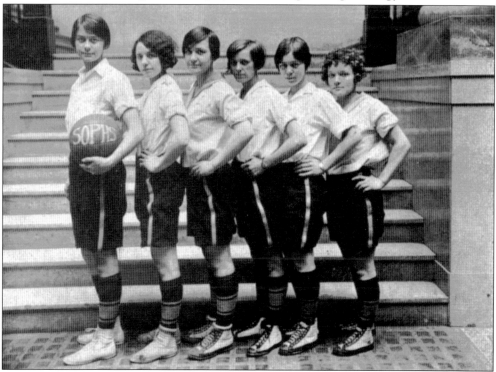

The 1927–1928 academic year was a turning point for women's basketball as it began to produce all-conference–caliber athletes. Paid attendance, which was 50¢ for adults and 25¢ for students and children, grew as community interest in the competitions increased. Players' uniforms had also changed from the pre-1920s bloomers and middy blouses.

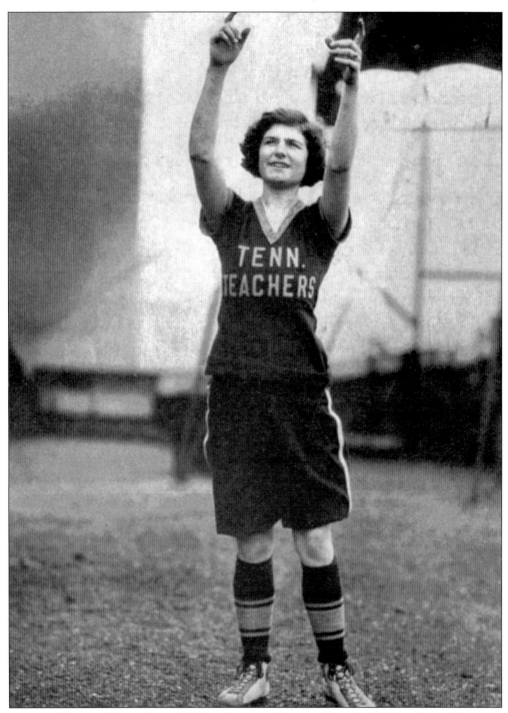

In 1927, Ellen Baird hit 57 out of 60 free throws to become the school's free-throw champion and the Tri-State Free Throw Champion. She repeated these local titles the following year and at the 1928 World Free Throw Championships held in Charleston, South Carolina, where she won a play-off by sinking 60 out of 60 baskets. She won this championship three years in a row.

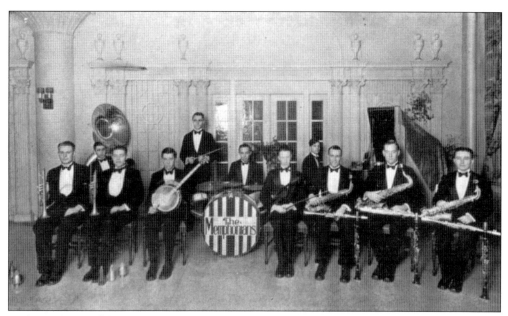

In the tradition of the 1920s Jazz Age, Maurice Haste organized West Tennessee State Teachers College's first jazz band, the Memphonians, in September 1927. Along with the school's orchestra or chorus, the Memphonians played at many of the college's social functions.

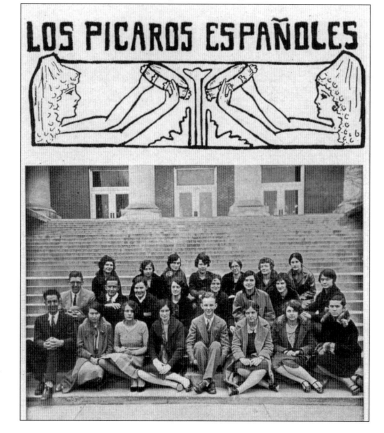

The school's first Spanish club, Los Picaroes Espanoles ("The Spanish Rascals"), was formed in 1927 to promote Spanish language instruction in the area's secondary schools. The club also encouraged faculty and administrators to upgrade the language program to a four-year sequence. In its first year, 22 students joined the club.

The John W. Brister Library was constructed in 1928. The building was originally named in memory of President Brister's son, J. Willard Brister Jr., who died following a brief illness shortly after construction began. In 1939, the library was formally renamed for President Brister by act of the State Board of Education. The library's entrance featured four columns similar to those of the Administration Building and marble steps.

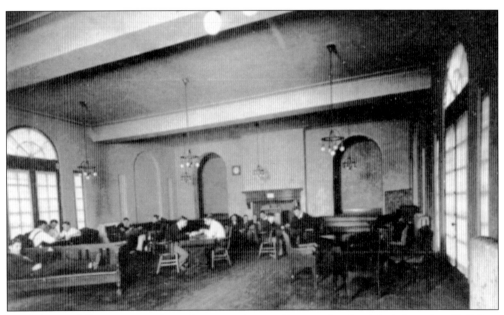

Until Brister Library opened, students used a small room in the Administration Building or traveled downtown to use the library facilities at the Goodwyn Institute. Pictured here is the large airy reading room, a prominent feature of Brister Library. Pobricita Mynders, widow of the college's first president, served as librarian from 1914 through the 1930s.

Dr. Nellie Angel Smith is pictured fifth from the right in the front row of this 1928 photograph of the Latin Club. Smith also organized Latin competitions for campus and community students.

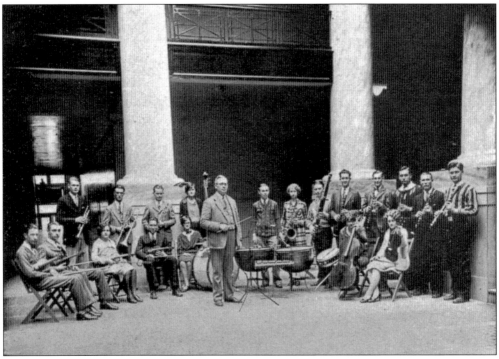
The college orchestra is pictured in the central foyer of the Administration Building in this 1928 photograph.

The West Tennessee State Teachers College chorus gathers for its annual yearbook photograph.

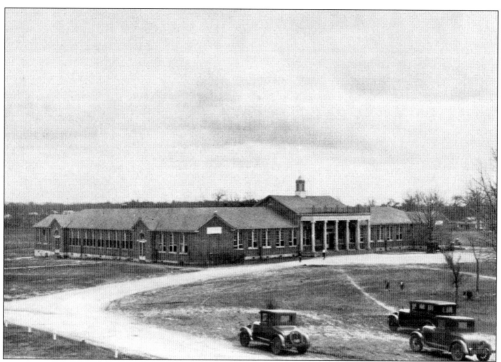

WTSTC's Training School, pictured in this 1929 photograph, was built with a joint grant from the City of Memphis and Shelby County. Originally housed at nearby Messick High School, the Training School moved to the Administration Building in 1917. The Training School allowed future teachers to practice their skills in elementary school classrooms.

Future Teachers IN the Making

Teacher training classes were conducted at the WTSTC Training School, later known as the Campus School. The Training School added grades and eventually provided instruction for high school teachers. The college inaugurated curriculum A for those pursuing a teaching certificate in elementary grades and curriculum B for high school teachers.

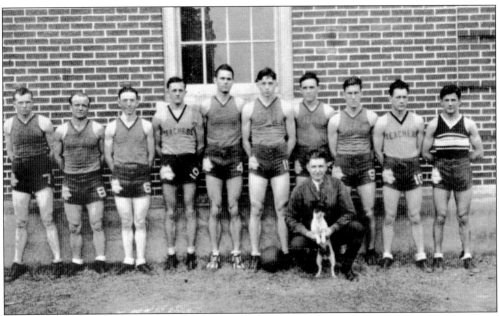

In this photograph, coach Zach Curlin and his dog pose with the 1929–1930 men's basketball team.

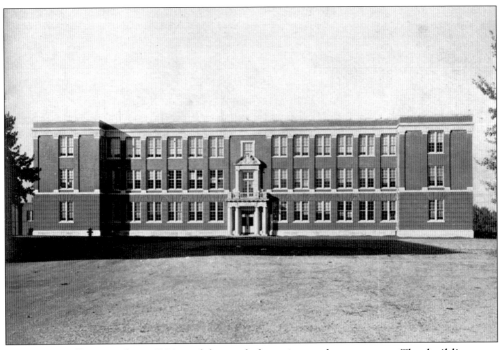

Manning Hall opened in 1930 and housed the science departments. The building was named for Priestly Hartwell Manning, a physics professor and dean of the college. Manning was a member of the faculty when the normal school began classes in 1912. He donated the bulk of his estate to establish one of the school's first scholarship funds for male students who were not athletes.

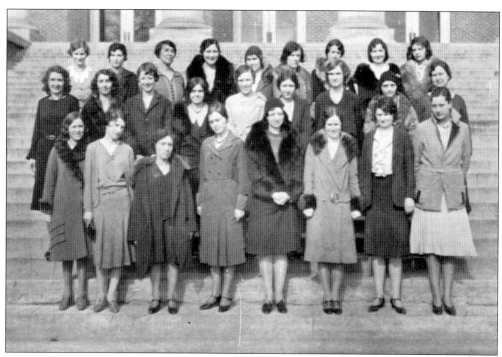

The Association of Childhood Educators is pictured in its 1931 yearbook photograph.

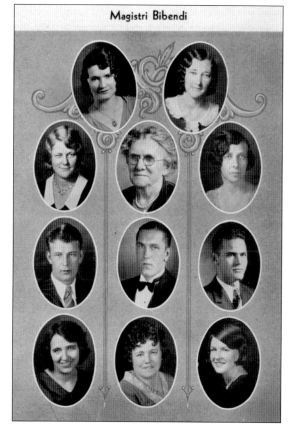

Magistri Bibendi was one of many organizations active on campus in the 1930s. Specific information on its membership and purpose no longer exists, but this photograph seems to indicate that it was a faculty club.

The men's baseball team is pictured in their distinctive "Teachers" jerseys.

WTSTC men's sports coaching staff included, from left to right, Jimmy Grisham, (freshman football coach), Zach Curlin (basketball coach), Allyn McKeen (head football coach), and C.C. Humphreys (line coach for the football team). Humphreys, who came to WTSTC in 1937 to teach history and work as assistant coach, became the institution's president in the 1960s.

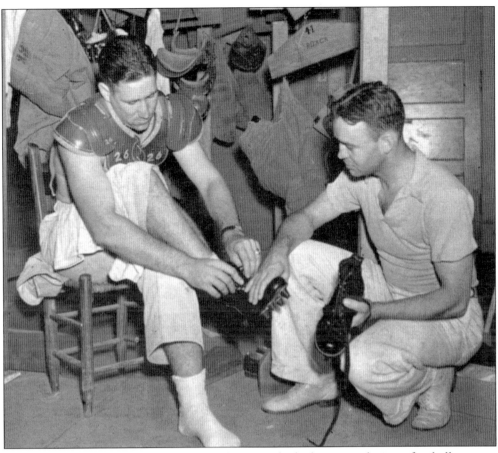
Coach Allyn McKeen tends to one of his players in the locker room during a football game.

The men's football team scrimmage in their 1930s-era leather helmets.

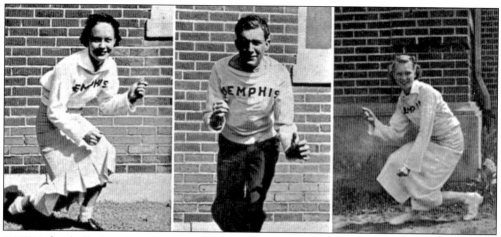

WTSTC football cheerleaders, from left to right, Joyce Brown, Ekillis Chandler, and Ione Goff cheered on the Teachers' teams in their intercollegiate competitions.

These candid photographs of the Seymour A. Mynders's fraternity are from the late 1930s. Many of the members pose in costume because they were photographed before or during skits they put on to entertain the student body. The bottom two photographs show pledges, or "rats," during their pledging periods.

This 1937 photograph shows the "maids" of Xi Beta Nu. The sororities required their pledges to dress up as chambermaids and whitewash the steps of the Administration Building. They also demonstrated their allegiance to their chosen sorority by wearing their costumes to class.

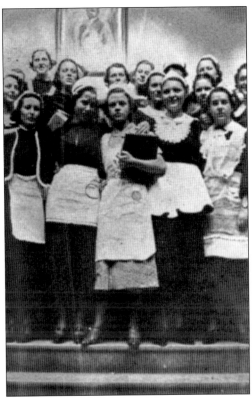

Greek-letter organizations created most of the social activities on campus through the WTSTC period. These three costumed coeds participated in a show put on by their sorority.

Sigma Alpha Mu required pledges to dress up as shepherdesses and herd sheep during their hell week activities.

At the end of the pledging periods, big brothers and big sisters required the pledges to demonstrate their loyalty to the Greek-letter organizations. Some of these activities had to be performed on the steps of the Administration Building. In this photograph, white-clad Kappa Lambda Sigma pledges pose with a goat in front of a crowd of onlookers.

These candid photographs of the activities of Kappa Lambda Sigma members and pledges suggest that Greek life at WTSTC was similar to that of other college campuses in the 1930s.

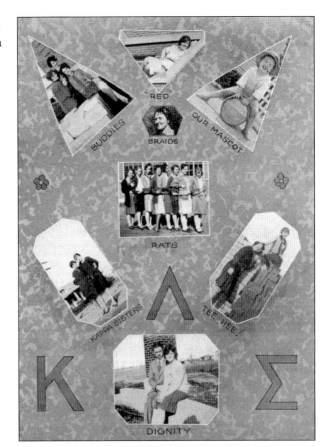

This pledge pushes pennies across the steps of the Administration Building as an initiation activity.

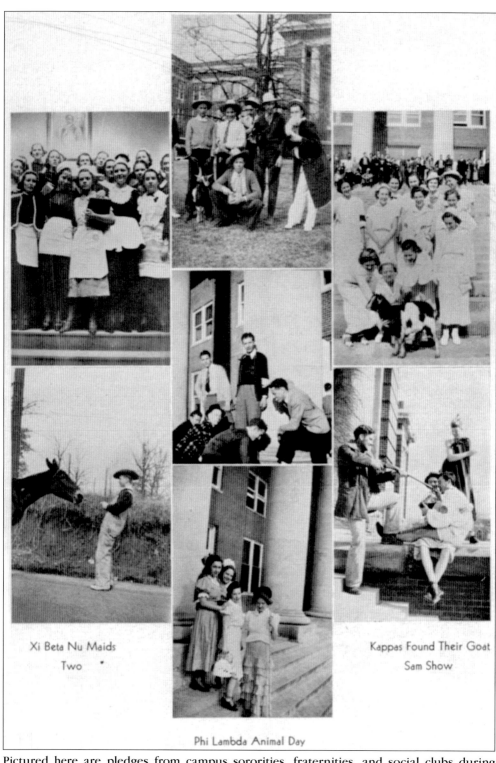

Xi Beta Nu Maids
Two

Phi Lambda Animal Day

Kappas Found Their Goat
Sam Show

Pictured here are pledges from campus sororities, fraternities, and social clubs during pledge-week activities.

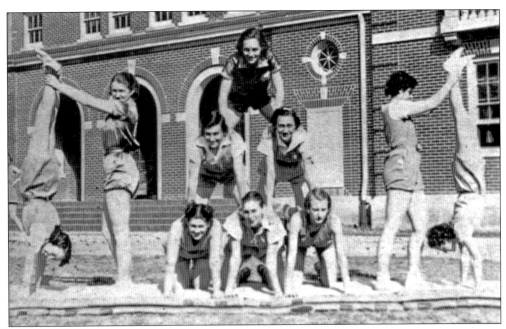

Until the late 1930s, female students at WTSTC participated in intercollegiate sports. However, in 1938, budget constraints led the SBE to end women's intercollegiate competition at the college. For the next 35 years, women were limited to intramural competitions. Track, gymnastics, volleyball, and tennis became popular options. Shown here is the women's intramural tumbling team.

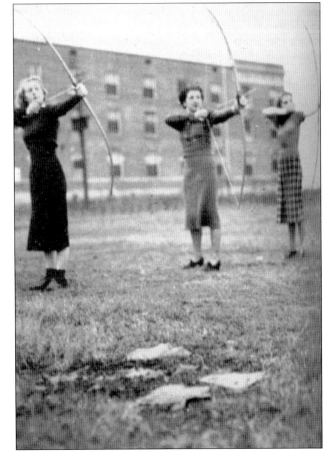

Women engaged in a variety of physical education courses, including archery, calisthenics, and table tennis.

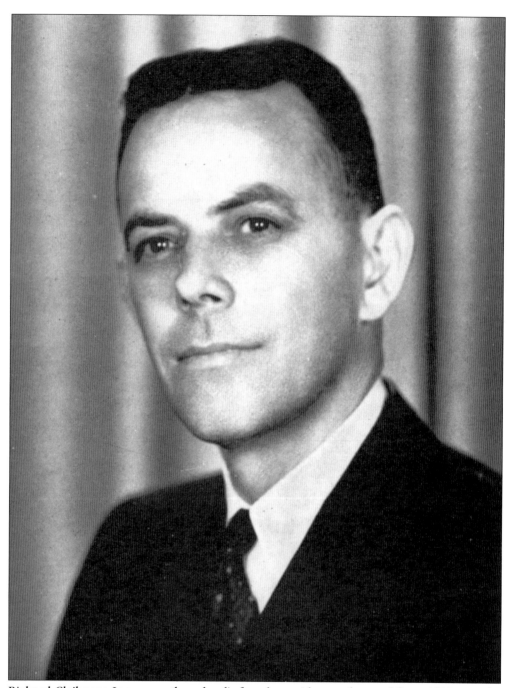

Richard Claiborne Jones was the school's fourth president and served from 1939 to 1943. Jones had served as interim president and, later, as acting president during the illness and subsequent death of Pres. John Willard Brister. Jones was elected president on September 10, 1939. He served through the early years of World War II until his resignation in 1943.

Female students leave Mynders Hall, possibly for an afternoon in town.

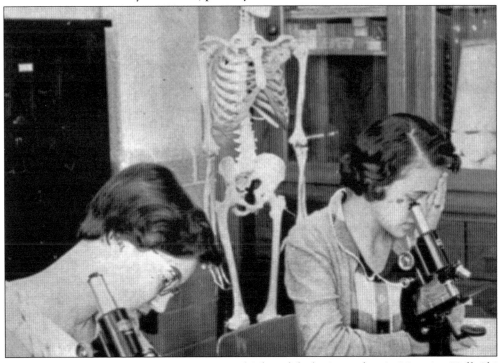
Two young women examine specimens in a biology lab during a class in Manning Hall. Phi Beta Chi, the first science club, was organized in 1940 to promote excellence in science education. To qualify for membership, a student needed to complete 21 quarter hours in one scientific field, eight quarter hours in a second scientific field, and maintain a B average.

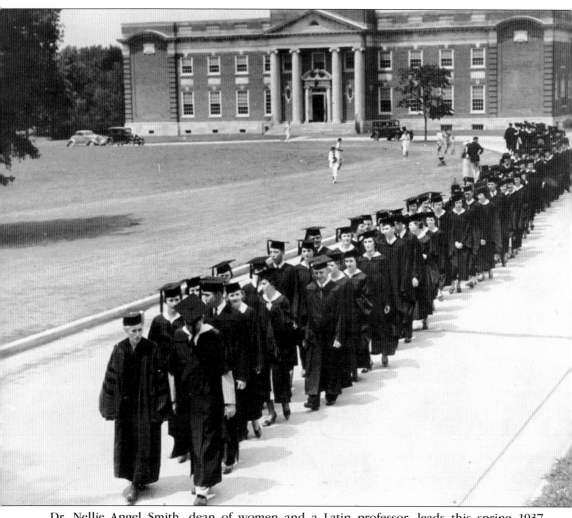
Dr. Nellie Angel Smith, dean of women and a Latin professor, leads this spring 1937 faculty convocation.

Three
MEMPHIS STATE COLLEGE
1941 TO 1957

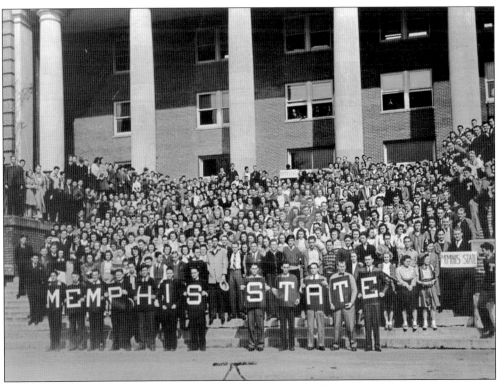

Students gather on the steps of the Administration Building to celebrate the expansion to a full, four-year liberal arts college and the subsequent name change to Memphis State College (MSC) in 1941.

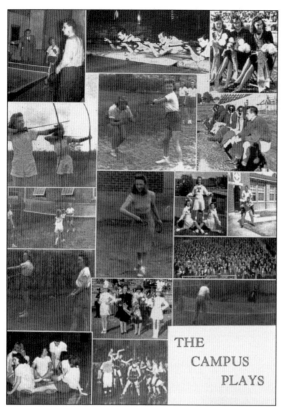

This photograph collage highlights the variety of activities available to students at Memphis State College.

Fraternity initiates serenade their big brothers during pledge week in 1940. Despite the economic downturns of the Great Depression, students at Memphis State College maintained an active calendar of social activities.

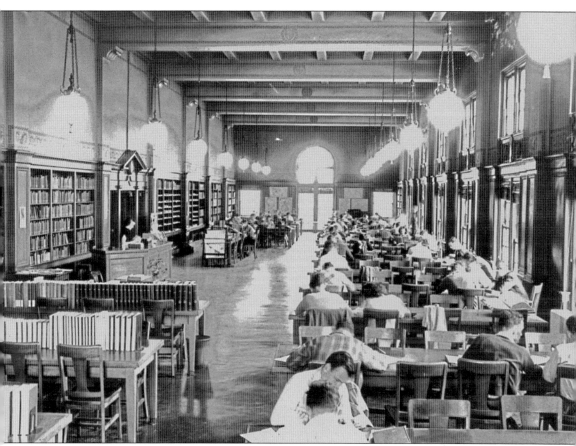
The open, airy reading room in Brister Library was a favorite study spot for students.

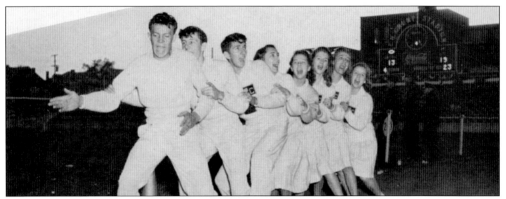

Cheerleaders perform during a football game in the fall of 1940 at Crump Stadium. Cheerleading squads were balanced gender-wise, despite the smaller number of male students on campus.

Memphis State College formed its first marching band in 1940. The marching band was organized to work hand in hand with the cheerleaders to raise school spirit and was part of the school's strategy to encourage a stronger relationship between Memphis State and the community.

These students ride in a convertible during the 1941 homecoming parade. The three male passengers wear Memphis State College beanies, which were sold to raise money to help football players purchase their textbooks.

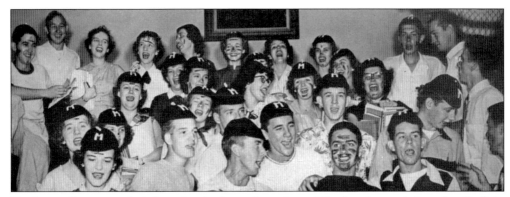

Freshmen first wore their beanies during orientation while they learned the school's fight song. The beanies, sold in the bursar's office, cost 75¢. Freshmen were required to wear their beanies for the first six weeks of school. A typical challenge from an upperclassman to a freshman was, "Freshman, square that beanie!" Freshmen rules required them to obey all reasonable commands and requests from upperclassmen.

Glider Pilot Conley Heaberlin makes a last-minute check.

The Civil Aeronautics Authority's Pilot Training Program was based on a program developed in 1937 by Memphis aviation pioneer Phoebe Fairgrave Omlie. When the program became the War Training Service in 1942, slots for women were eliminated because pilot trainees were required to enlist in the military. Despite this restriction, four Memphis State women—Joy Jehl, Martha McKenzie, Agnes Walker, and Pauline Mixon—completed pilot training through the federally funded program.

The school's National Youth Administration (NYA) program began in the mid-1930s as a part of the New Deal's Works Progress Administration. Memphis State's NYA shop buildings, completed in 1941, were devoted to vocational activities in support of national defense.

Students assemble letter boxes in the NYA building. Their vocational course work included classes in furniture making and other tasks that were used to set up offices for wartime mobilization.

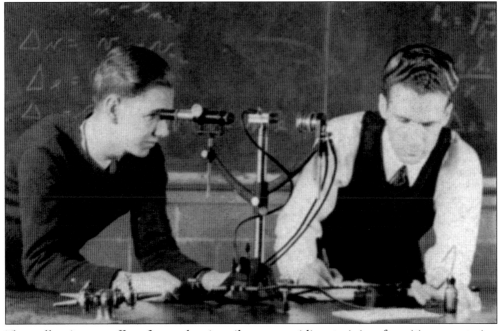

The college's war effort focused primarily on providing training for citizens entering wartime industries. This training included broadening the school's science course offerings. Pictured here are members of the university's first science club, Phi Beta Chi.

These nurse cadets attended Memphis State for their preparatory science classes before completing training at local hospitals. Nurse cadet training began its affiliation with Methodist Hospital in 1939 and with Baptist Hospital in 1945.

Sorority groups were encouraged to use the third-floor lounge in Mynders Hall as headquarters for a Red Cross unit. Students gathered there to knit socks and scarves and roll bandages.

As this poster suggests, Memphis State Tigers wholeheartedly supported the war against the Nazis.

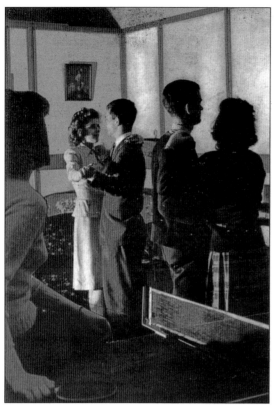

During the war, campus events doubled as United Service Organization (USO) activities to accommodate the Army Air Corps cadets living on campus. MSC coeds served as USO hostesses for events around the city.

These MSC coeds take a break to chat near a military vehicle on campus.

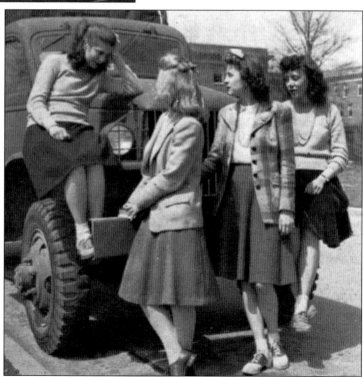

Some of the smallest classes in the school's history graduated in 1944 and 1945. Enrollment dipped to 990 students (the lowest since the third year of the normal school) when the Army Air Corps cadet program left the campus in 1944. Pictured here is the 1944 homecoming court.

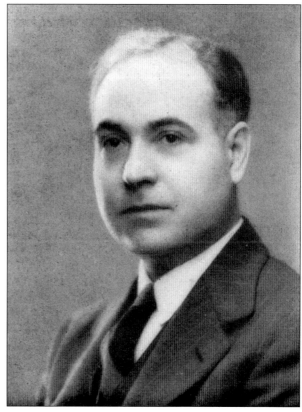

Jennings Bryan Sanders was the sixth president and served from 1943 to 1946. He also served as professor and chair of the History Department at the University of Tennessee from 1935 to 1942. When he became president of MSC, Sanders was the youngest person to hold that position and the first with a PhD. Sanders assumed the presidency, pledging to restore Memphis State College to full SACS accreditation. Having accomplished that in June 1946, he tendered his resignation.

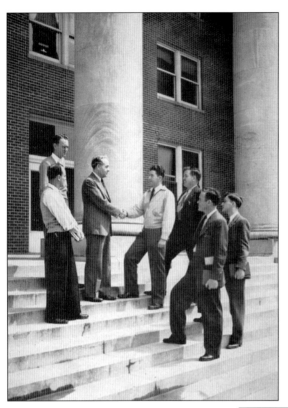

MSC's student population grew slightly in 1945 as the first recipients of the GI Bill matriculated on campus. In the photograph, Pres. Jennings Sanders welcomes a group of veterans to Memphis State College.

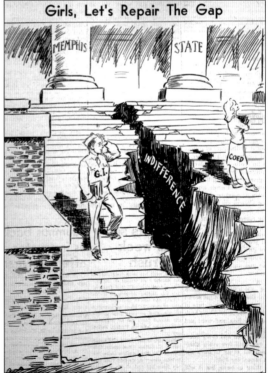

This editorial cartoon from a spring 1946 issue of *The Tiger Rag* suggests that the veterans' transition to college life was not as smooth as they had hoped.

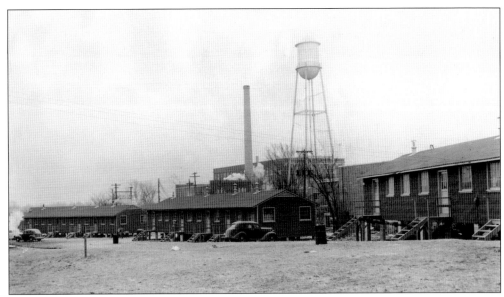

In 1946, the Federal Surplus Housing Administration donated several buildings to Memphis State. The government moved and erected the buildings on campus behind Manning and Jones Halls to house married veterans and their families who attended the school under the GI Bill.

Members of the Memphis State Veterans' Association pose on the steps of the Administration Building. The association formed at the beginning of the fall 1946 quarter. By the spring quarter, the membership numbered 300 ex-servicemen. Its primary purpose was to promote "a better understanding among the veterans themselves and a true feeling of comradeship among all." The group sponsored a clothing drive for the destitute people of Europe and held their first social function in the spring, a formal dance at the University Center.

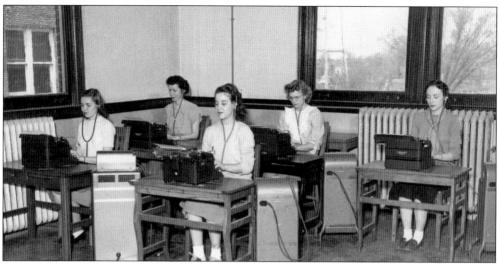

Women type up notes from Dictaphone recordings in business class. The college always provided technical training courses in home economics and agriculture. During and after World War II, these courses evolved to training for industry.

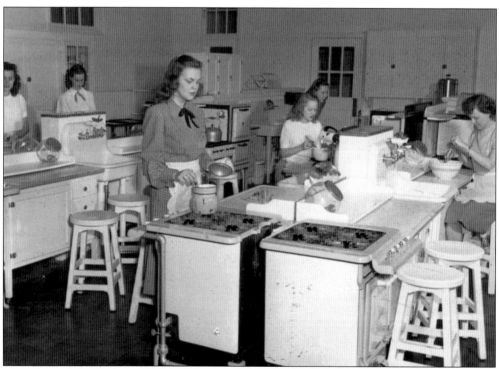

Although campus women made strides in nontraditional arenas (such as science and aviation) during the war, home economics classes remained popular and were seen as important preparation for young women's future roles as housewives and mothers. The Home Economics Club offered a home nursing course and covered topics like preparing nutritious meals using ration points.

By 1951, coeds could socialize with their male guests in the parlor. Although the rules had eased, men were still only permitted to visit the women's dorm at specific hours, and they could not wear Bermuda shorts when they visited the women. Women were not allowed to wear pants or shorts on campus, except during athletic activities, until the early 1960s. The young women in this photograph socialize in the remodeled parlor of Mynders Hall.

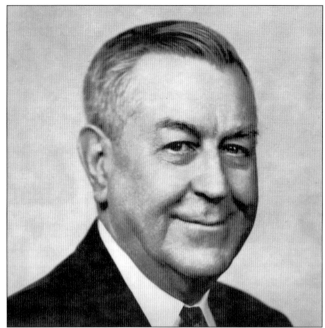

James "Jack" Millard Smith—seventh president, from 1946 to 1960—was the first alumnus to become president of the school. He joined the school's administration in 1927 as manager of the new men's dormitory, became principal of the Training School and Director of Teacher Training in 1930, Dean of the college in 1933, and registrar from 1936 to 1937. He resigned in 1937 to become president of Tennessee Polytechnic Institute. He left Tennessee Polytechnic Institute in 1940 to become director of instruction for Memphis city schools.

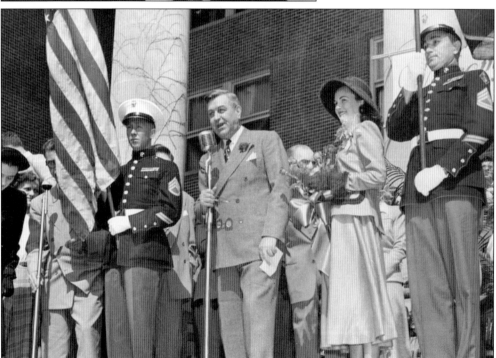

Barbara Jo Walker was the college's first coed to win a national beauty competition. She was chosen Miss America 1947 after competing in the contest as Miss Memphis. She was the last representative of a city, not a state, to win and the last winner to be crowned in a bathing suit. She is shown here with Pres. J. Millard Smith as he declared Miss America Day on campus. After her year as Miss America, Walker returned to MSC to complete her degree and marry her fiancé, Dr. Vernon Hummel.

This aerial view of the 80-acre campus in 1947 shows Normal Depot among the trees at bottom right and the streetcar turnaround at bottom left. A streetcar ride to Memphis took 45 minutes and cost 5¢.

ROTC

Air Force ROTC was established on campus in 1951. AFROTC was a compulsory program for all male students until the State Board of Education made it voluntary in 1971. In 1981, Army ROTC joined the AFROTC on campus; Navy ROTC followed in 1983, making Memphis State one of only 30 higher education institutions in the country to host all three ROTC branches.

This photograph shows the 1952 graduating class procession into Memorial Gymnasium for their commencement ceremony.

Male students socialize in front of the Administration Building in 1951.

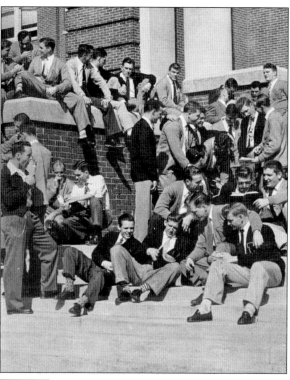

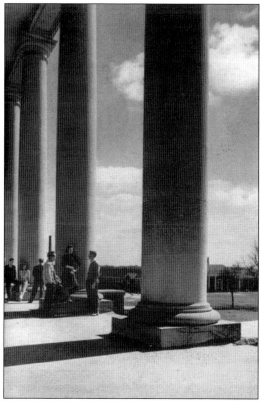

This photograph shows the view through the columns on the porch of the Administration Building. From the school's beginnings, this was a central location for campus activities. In 1972, wear and tear on the steps, coupled with the need to make the Administration Building handicap-accessible, led to the removal of the stairs and relocation of the main entrance to the former basement.

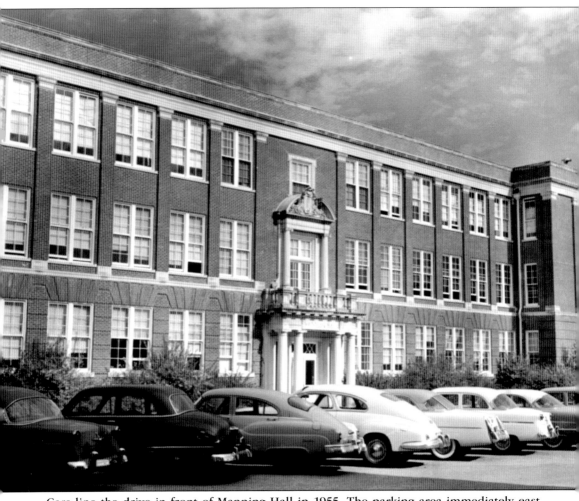
Cars line the drive in front of Manning Hall in 1955. The parking area immediately east of Manning Hall was one of the largest on campus and provided spaces to residents of Scates Hall.

The Memphis State Five (from left to right, Mardest Knowles, Nellie Peoples, Joseph McGhee, Ruth Booker, and Elijah Noel) was the original group of African American students who attempted to desegregate the college in 1954. At right, the group talks in the main hall of the Administration Building.

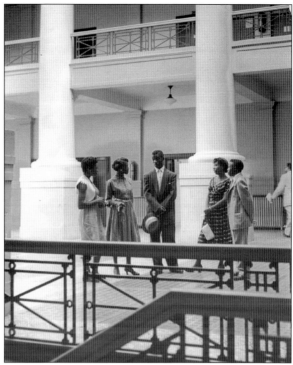

Though willing to meet with the prospective students, President Smith resisted integration of the school. He was eventually forced to capitulate to a Federal Court order and allow African American students to matriculate in the fall of 1959. Smith resigned at the end of the term, before the first black students arrived on campus.

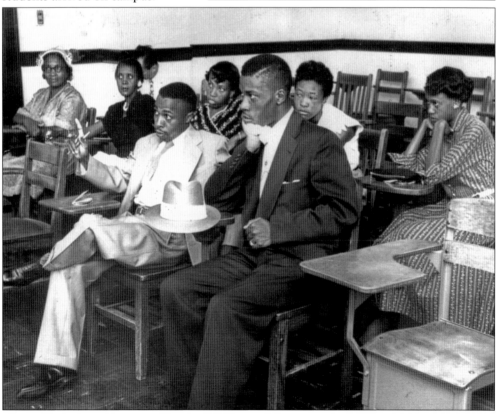

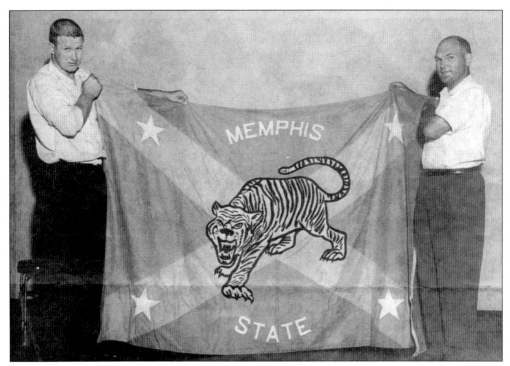

The new Memphis State College fight flag was revealed in 1955 by then football coach Ralph Hatley (right) and a former player. Commercial Appeal cartoonist Cal Alley designed the flag for the college.

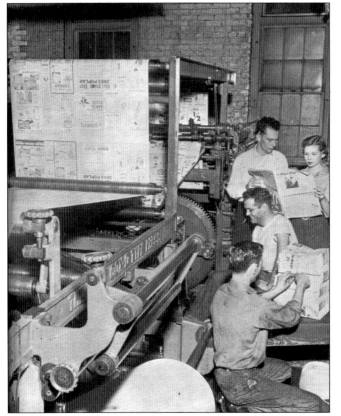

Students print copies of *The Tiger Rag* on the university's printing presses in 1956. The Journalism Club published the first issue of *The Tiger Rag* in 1931. The newspaper became *The Helmsman* in 1971 as students sought to diminish the university's reputation as "Tiger High."

In the 1950s, the campus Greek system incorporated national fraternities and sororities in place of the local Greek organizations that had existed at the school for the previous 43 years. The students enjoy a Sigma Alpha Epsilon's forty-niner party.

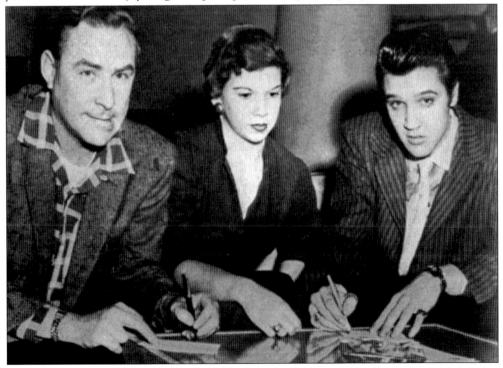

Memphis deejay Dewey Phillips (left), DeSoto yearbook editor Judy Crainer, and Elvis Presley sign pledge cards asking Gov. Frank Clement to grant university status to Memphis State.

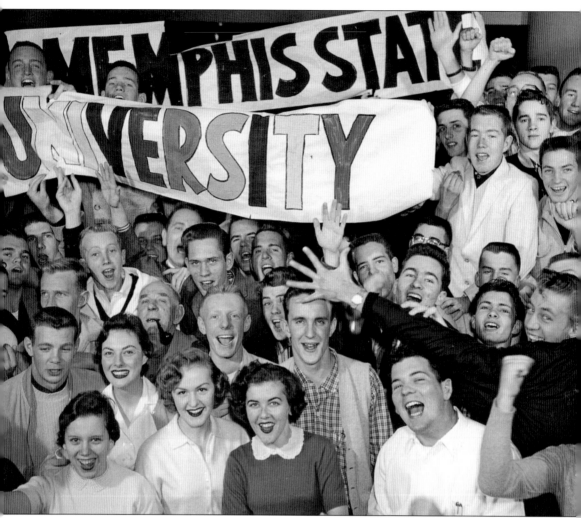
Students cheer the announcement that Memphis State College has become Memphis State University (MSU) in 1957.

Four

MEMPHIS STATE UNIVERSITY

1957 TO 1994

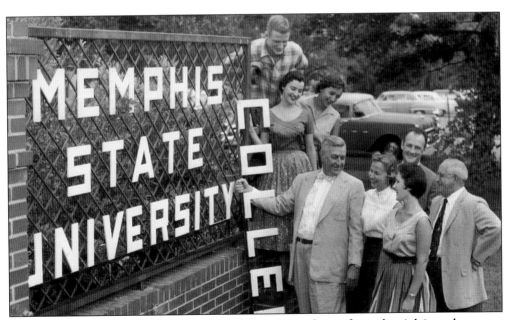

Pres. J. Willard Smith (center), C.C. Humphreys (second man from the right), and a group of students celebrate the creation of Memphis State University by changing the sign at the southwestern edge of campus in July 1957. The school's original supporters had hoped that the school would evolve into a university that would serve the mid-South region. In pursuit of that goal, presidents of the West Tennessee Normal School, West Tennessee State Teachers College, and Memphis State College worked to broaden the school's curriculum. In cooperation with the University of Tennessee, the school offered a master's degree in education in 1955.

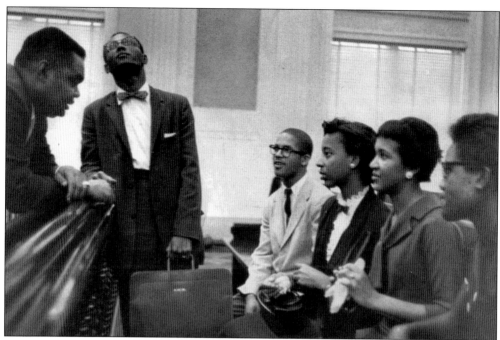

In 1959, the Memphis State Eight successfully integrated Memphis State University. In this photograph, the students meet with their attorneys during their protracted court battle in September 1958.

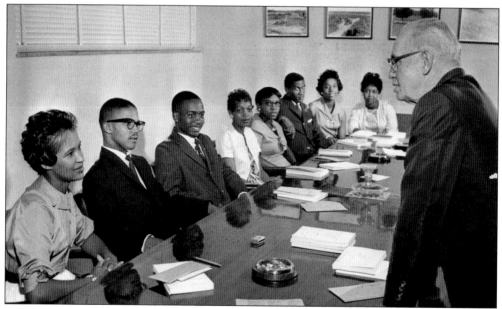

The Memphis State Eight meet with the University's registrar, R.M. Robison, to enroll in courses for the fall 1959 semester. Robison and the university's bursar, Lamar Newport, were charged with making certain that integration at Memphis State would not be marred by violence. The students in this photograph are, from left to right, Sammie Burnett, Ralph Prater, Luther McClellan, Eleanor Gandy, Bertha Mae Rogers, John Simpson, Marvis Kneeland, and Rosie Blakney.

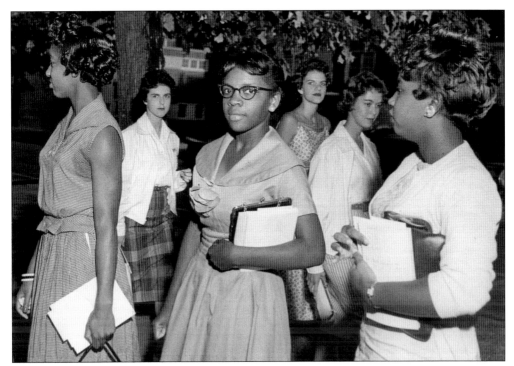

Pictured above, three white coeds walk behind Rosie Blakney, Bertha Mae Rogers, and Marvis Kneeland. While there were no formal outbreaks of violence, university administrators took stringent measures to contain the student body and minimize the chances for violent encounters. Black students were only allowed to take morning classes and could not live in the dormitories or use the school's cafeteria facilities. They were also accompanied by police escorts while on campus and had to leave campus promptly after their classes.

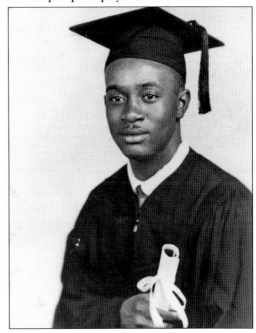

Luther McClellan was the first black graduate of Memphis State University in May 1962. McClellan was chosen as one of the Memphis State Eight because his World War II military service entitled him to a publicly funded college education under the GI Bill.

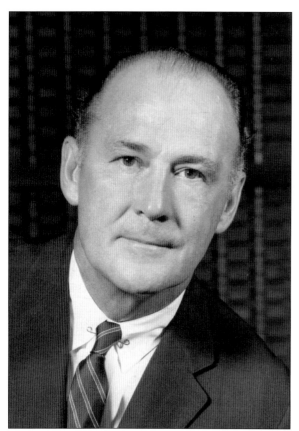

Cecil C. Humphreys—the seventh president, from 1960 to 1972—first came to the university to teach history and serve as an assistant football coach in 1937. He held various positions in the state education system and served with the FBI and in the Navy during World War II. He returned to Memphis State in 1947 to serve under Pres. Jack Smith as director of athletics and director of the graduate school. During his tenure as the university's president, Humphreys oversaw the largest expansion in enrollment, facilities, and programs in the school's history.

MSU had its first integrated homecoming court in 1966. Carla Allen (left) was first alternate to homecoming queen Toni Chiozza. Second alternate Sandra Hooper is pictured on the right.

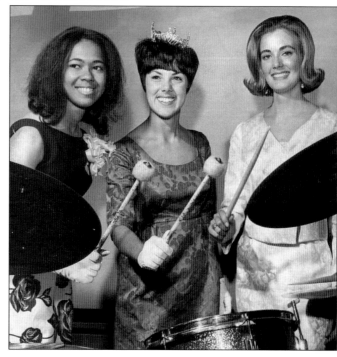

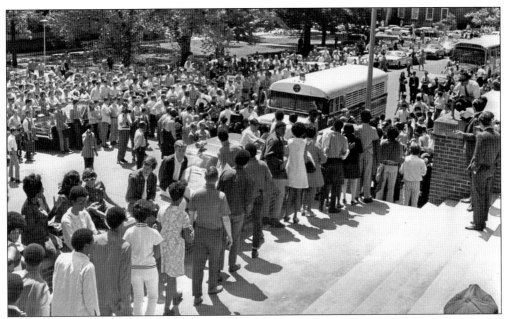

Although the school was formally desegregated in 1959, full incorporation of African American students into the MSU student body was a much slower process. On April 28, 1969, one hundred and three black students and six white students staged a two-hour sit-in at President Humphrey's office to demand a black studies curriculum, the hiring of an African American dean, more black instructors, and better racial integration of the athletic program. Students also protested the continued presence of policemen on the campus following a similar demonstration the previous week. Students were arrested during the April 28th demonstration, and the photograph above shows them loading buses for transport to the county jail.

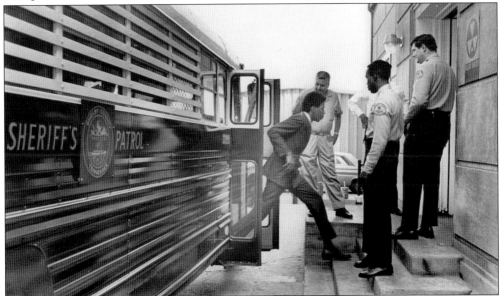

A student demonstrator exits the sheriff's patrol bus that transported him from the MSU campus to the county jail following the April 28th demonstration.

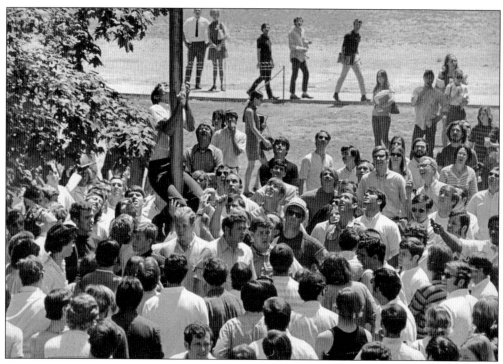

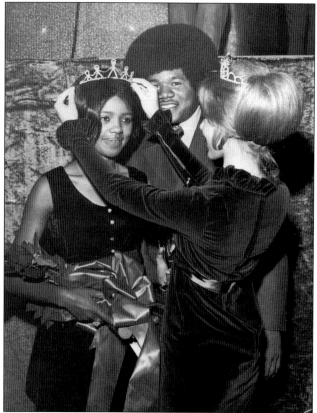

During a demonstration protesting the killing of four Kent State University students by Ohio National Guardsmen in May 1970, a Memphis State student climbs the flagpole in an attempt to lower the flag to half-mast. Other students moved to prevent the gesture, and an altercation ensued.

In 1970, Maybelline Forbes, shown here with her escort, Ronald Johnson, was crowned the university's first black homecoming queen by outgoing queen Linda Venable. Forbes's reign was not without controversy. Mayor Henry Loeb refused to shake hands with her during the homecoming parade, and the captain of the football team refused to escort her to center field, as was traditional for homecoming festivities.

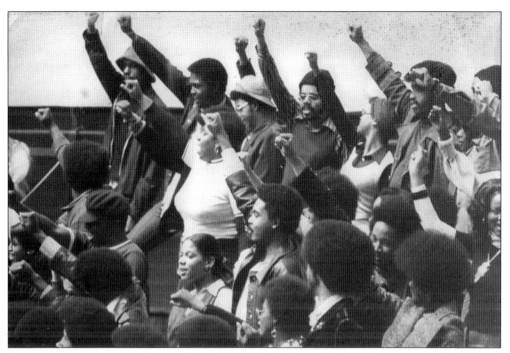

Student protests continued into the early 1970s. In December 1973, members of the Black Student Association refused to stand during the "National Anthem" and raised their hands in the black power salute at a Tigers' basketball game.

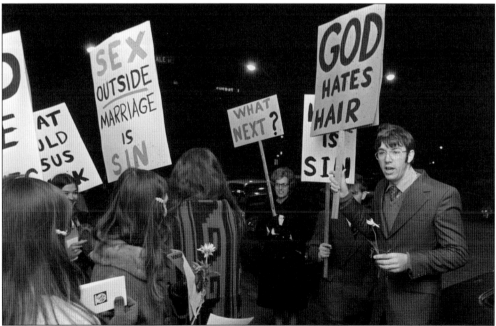

Students and concerned members of the Memphis community protest outside the MSU production of the controversial musical *Hair* in 1970. The production, staged by Keith Kennedy, MSU's first theater director, played to sold-out audiences, but Kennedy omitted the infamous nude scene. (Courtesy of the Commercial Appeal.)

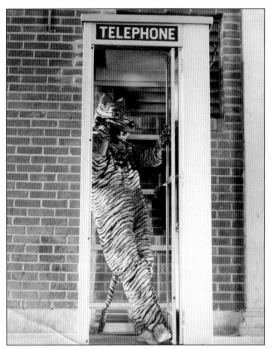

"Pouncer" J. Wayne Johnson makes a telephone call in 1962. Johnson originated the mascot in 1961, and even purchased his costume with his own money. He later led the student effort to obtain a live animal mascot for the football team.

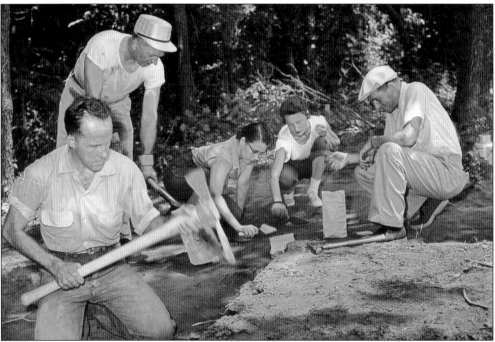

Charles H. Nash (left) demonstrates excavation techniques to visiting students at Chucalissa around 1960. Chucalissa is the site of a Mississippian mound complex (1000 AD to 1500) uncovered by Civilian Conservation Corps workers at T.O. Fuller State Park in 1938. Nash began work at the site in the mid-1950s and was the founding director of the C.H. Nash Museum at Chucalissa. He continued in this position and taught anthropology and general ethnology classes at MSU after the university acquired the site and the museum in 1962.

Brister Library served the campus community until 1994. The library's holdings increased, and the Mississippi Valley Collection was established to house items related to the university's and the region's history.

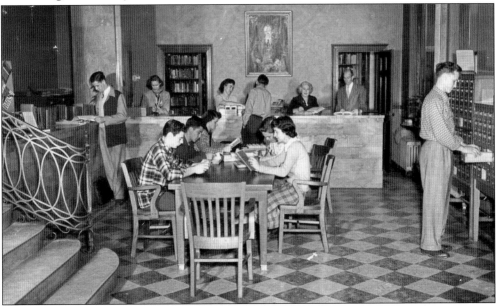

The library's circulation area was a hub for student academic activity. Although the Ned McWherter library currently houses most of the university's collections, some holdings remained in the original Brister Library structure through the 1990s. Brister still houses the Heritage Room, a collection of documents and memorabilia related to the university's history.

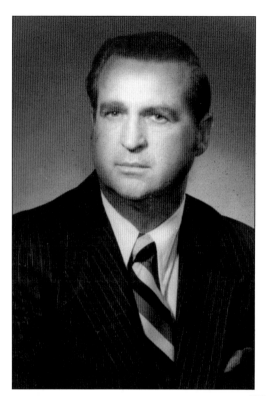

Billy Mac Jones was the eighth president, from 1973 to 1980. He received his BA degree from Vanderbilt, his master's degree from George Peabody University, and his PhD from Texas Tech University. He held administrative and academic positions at Middle Tennessee State University, Texas A&M University, San Angelo State University, and Southwest Texas State University, where he served as president.

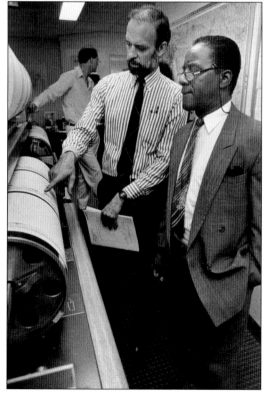

MSU's Center for Earthquake Research and Information recorded an earthquake in Cape Girardeau, Missouri, that measured 4.7 on the Richter scale. Dr. Arch Johnson (left), director of the center, points out the seismic activity recorded by the center's seismographs to Tennessee State Representative Alvin King.

Egyptologist Dr. Tim Kendall stands between statues of King Aspelta and King Analamani (left), the grandsons of King Taharqa. The statues are part of the permanent collection of the Memphis State Institute of Egyptian Art and Archaeology (IEAA).

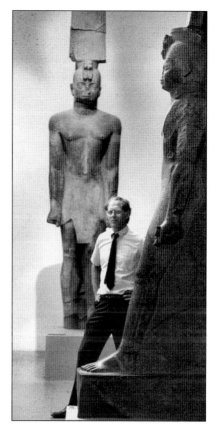

Graduate student John Meza lifts the coffin from the mummified body of Ankh Ptah-Hotep after the arrival of the sarcophagus in September 1983. The mummy was added to the permanent collection of the IEAA, which was established in 1975.

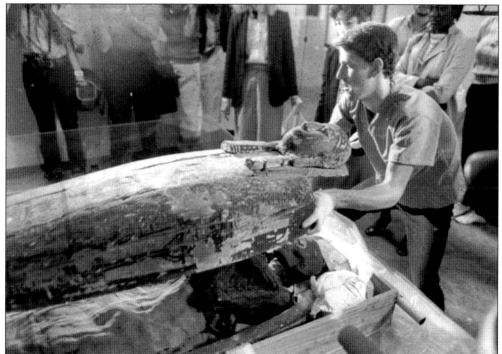

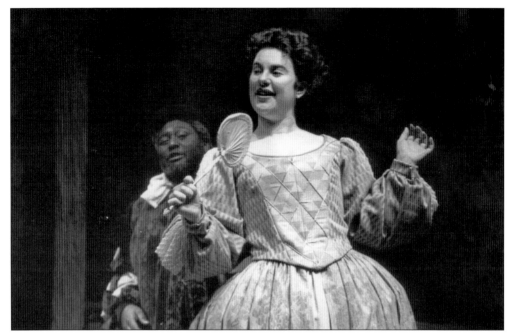

The School of Music is home to a nationally recognized opera program and has produced two to three operas each year since the program's inception in the early 1960s. Alumni include renowned soprano Gail Robinson, shown here.

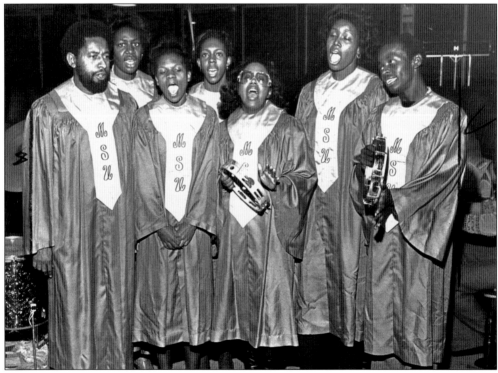

The School of Music also houses the gospel choir, a group of 30 to 40 singers who perform gospels and traditional African American spirituals.

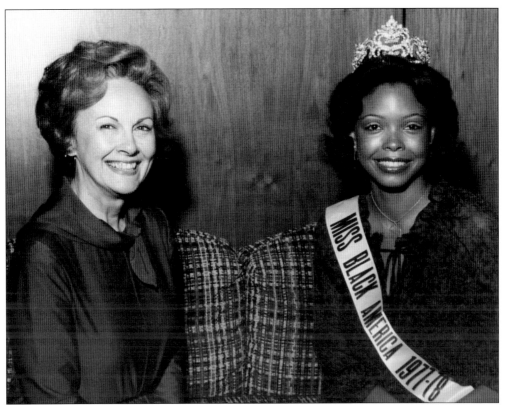

Memphis State University coed Claire Ford was crowned Miss Black America in 1977. She is pictured with another national beauty competition winner and university alumna, Barbara Walker Hummel, Miss America 1947.

Tiger cheerleaders rest on the sidelines during a basketball game at the Mid-South Coliseum in 1977. Tiger teams regularly played at the coliseum until construction of the Memphis Pyramid in 1991 and the FedEx Forum in 2004.

Yvonne Chapman and other cheerleaders practice before the 1973 homecoming game.

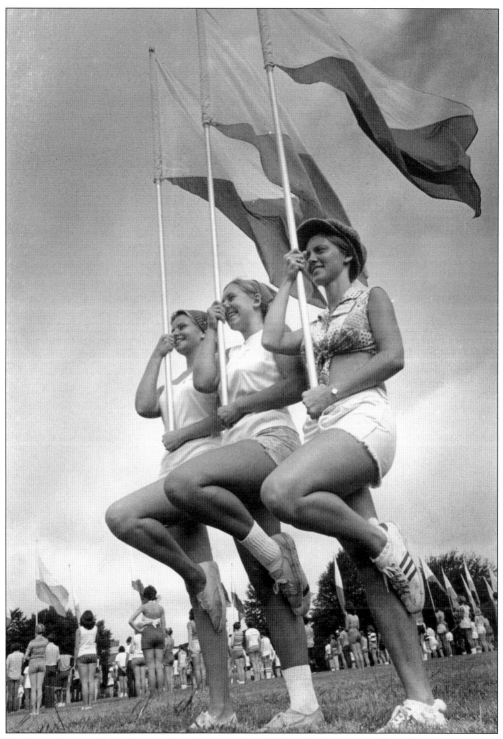
Kimberly Eggert (left), Sharon Smith (center), and Marceia More carry flags during a practice performance in 1965.

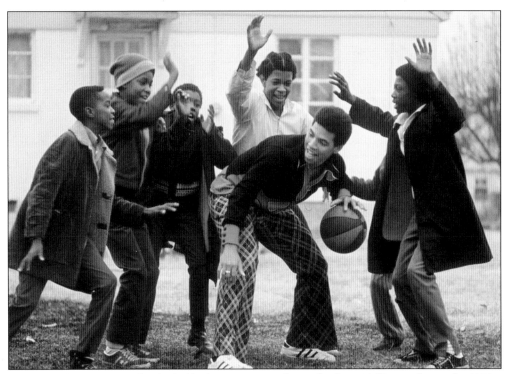

Larry Finch was a star basketball player at MSU from the late 1960s to the early 1970s. A graduate of Memphis Melrose High School, Finch was recruited by MSU coach Gene Bartow. During his senior year from 1972 to 1973, the Tigers won 14 straight games and advanced to the NCAA Final Four for the first time, losing to the UCLA Bruins at St. Louis. (Courtesy of the Commercial Appeal.)

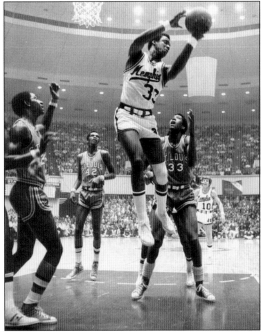

Ronnie "the Big Cat" Robinson is caught in a midair move during the 1973 game against St. Louis at the Mid-South Coliseum. Like teammate Larry Finch, Robinson was recruited from Melrose High School. Robinson played professional basketball for the Utah Stars, Memphis Tams, and Memphis Sounds in the 1973–1974 and 1974–1975 seasons.

Stan Davis, a graduate of Memphis Manassas High School, was Memphis State's "first Negro star" in the 1969 season. According to sports reporters, Davis was destined to "become a sports legend." He played for MSU from 1969 until 1973. The Philadelphia Eagles drafted Davis in 1973, but he only played one season of professional football.

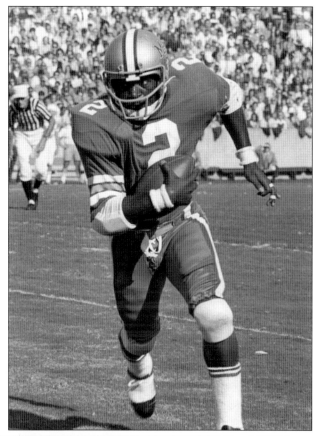

The first tiger mascot, TOM, was purchased and donated to the university by the Highland Hundred booster club. TOM lived in a habitat at the Memphis Zoo from 1972 until his death in 1992.

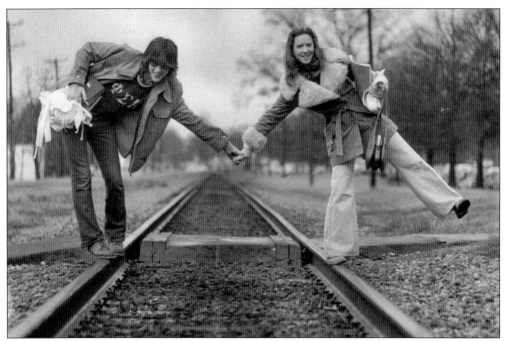

Siblings Al and Rose Mullins hold hands over the railroad tracks on the university's southern border in January 1976.

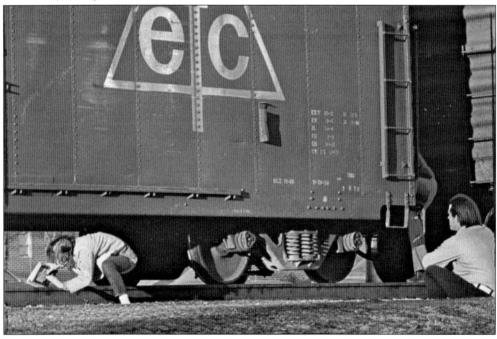

The State Board of Education required West Tennessee Normal School to construct the Normal Station at the campus's doorstep to help students commute to campus affordably by train. However, during the school's first 50 years, the trains running along Walker Avenue frequently hindered students' ability to get to class on time. Above, students take an extremely dangerous shortcut underneath a stalled railcar.

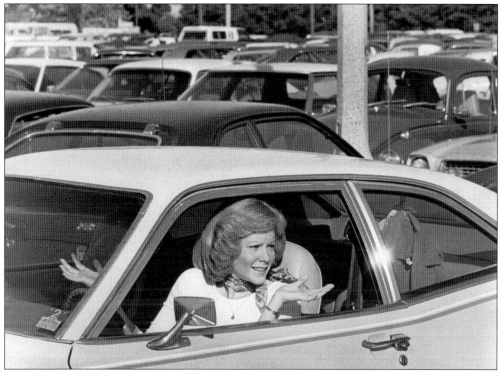

Parking problems escalated as MSU's commuter student population grew. In 1976, director of security Bob Rutherford noted that the university issued about 20,000 parking permits for the 6,800 on-campus parking spaces. Students like junior Cathy Hess, shown above, often searched in vain for legal parking spaces on campus.

The shortage of available campus parking spaces was an ongoing source of friction between students and residents who lived south of MSU. Anxious to get to class on time, students sometimes created their own parking spaces on front lawns or across driveways. Campus patrolmen, in an attempt to curb this activity, handed out an abundance of tickets in a relatively short time span. Robert Bellamy, pictured here, fans the 68 citations he distributed in less than two hours.

Thomas G. Carpenter, the ninth president, from 1980 to 1991, earned his BA degree from Memphis State College in 1949. He completed his master's degree at Baylor University and received his PhD from the University of Florida. Between 1956 and 1969, he served on the faculty or staff at several universities in Florida. In 1969, he became president of the University of Florida, a position he held for 11 years.

Ready to get their semester under way, Stephanie Marks (right) and an unidentified friend use a shopping cart to transport their belonging to dormitory rooms in the early 1980s.

Carrie Healey (left) and Stephanie Marks share the burden of moving boxes into dormitory rooms in the early 1980s.

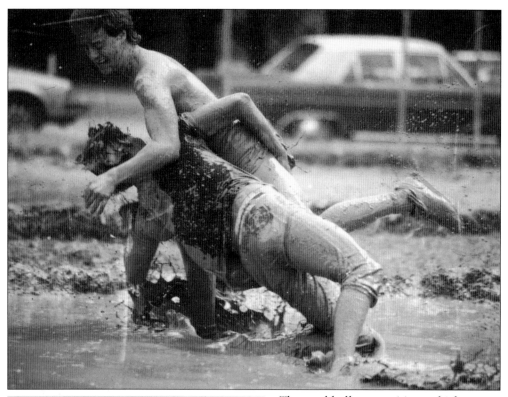

The mud-ball competition, which is volleyball played in six inches of mud, began in 1984 as a fundraising effort to benefit the J. Wayne Johnson scholarship program. The scholarship is named for the original Pouncer mascot.

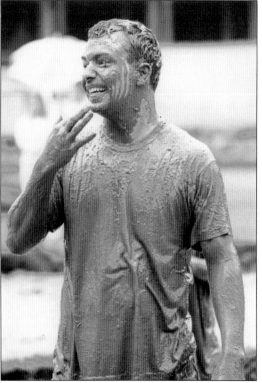

A mud-ball participant enjoys the action in the annual tournament.

Students find common ground as they savor a traditional Memphis meal of barbecue ribs during a campus activity.

Members of the Tiger marching band play during a half-time show.

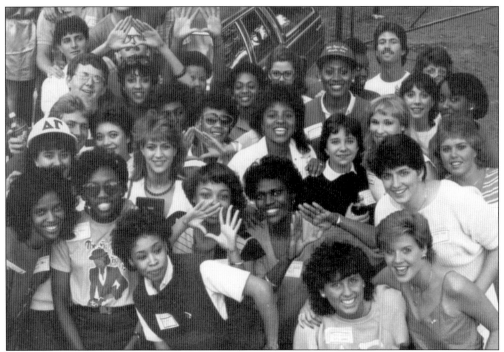

MSU's Delta Gamma and Delta Sigma Theta chapters pose for a group photograph at a Greek event in the early 1980s. The Epsilon Kappa chapter of Delta Sigma Theta was the first black Greek letter organization on the university's campus. It received its charter in 1963.

"Step" shows are a fixture in African American Greek life. As black students became more fully integrated into the university community, black fraternities hosted step shows on campus. The 1980s photograph above features members of Alpha Phi Alpha fraternity. The chapter was chartered in 1975.

Continuing the tradition of national beauty competition winners, Miss America 1987, Kelley Cash, a former MSU coed, takes time out from her busy schedule to pay tribute to her alma mater. Pres. Tom Carpenter presents her with a jeweled tiger pin to commemorate her visit.

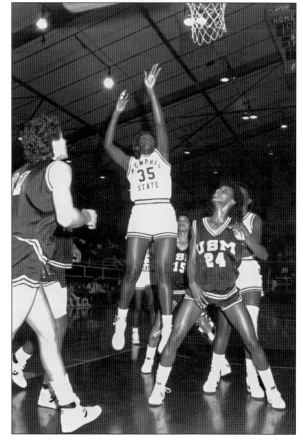

Women's basketball was equally if not more popular than men's basketball, with many MSU supporters. In the photograph, a lady Tiger makes a jump shot during a game with the University of Southern Mississippi in the early 1990s.

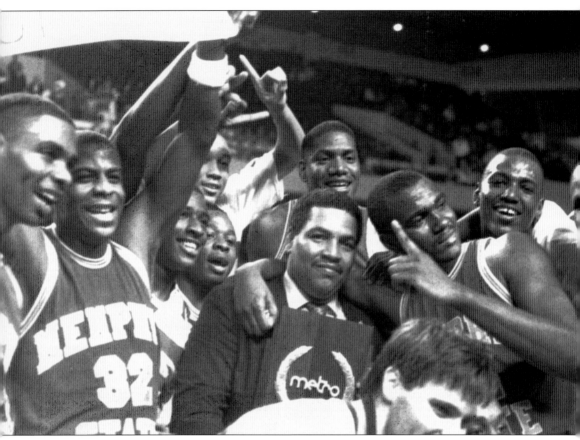

Larry Finch returned to Memphis State University in the 1980s as an assistant to basketball coach Dana Kirk. Finch became head coach in 1979, when Kirk was removed for NCAA violations. Finch coached the MSU Tiger basketball teams to multiple NCAA appearances between 1986 and 1997. Finch's winning 1992 squad included future NBA star Anfernee "Penny" Hardaway.

Five

UNIVERSITY OF MEMPHIS

1994 TO THE PRESENT

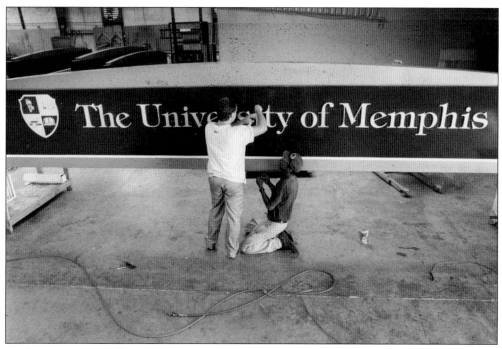

Workers construct the new University of Memphis sign in June 1994. Memphis State University became the University of Memphis for many reasons. Chief among these was the desire of the university's administration to distinguish the institution from other regional schools and to reflect its status as a major urban research institution.

The Ned R. McWherter Library was completed in 1994. Named after Gov. Ned R. McWherter, the library currently houses the majority of the University of Memphis's holdings, as well as the Mississippi Valley Collection.

V. Lane Rawlins, the 10th president, from 1991 to 2000, served as vice chancellor for Academic Affairs at the University of Alabama and vice provost at Washington State University prior to his appointment as president of MSU.

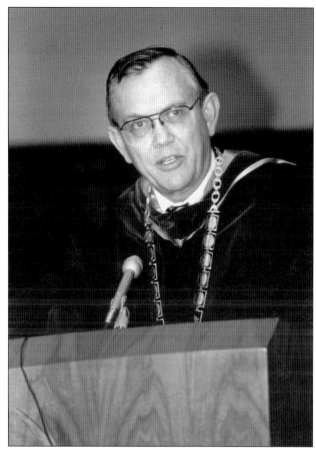

Former university president Tom Carpenter (left) and President Rawlins stand in front of the newly constructed Thomas S. Carpenter Student Housing Complex. The Carpenter Complex, completed in 1998, is a mixed living community that provides students with apartment or townhouse accommodations. These living spaces are leased on a year-round basis so that students can live in them through the summer months and over holiday breaks.

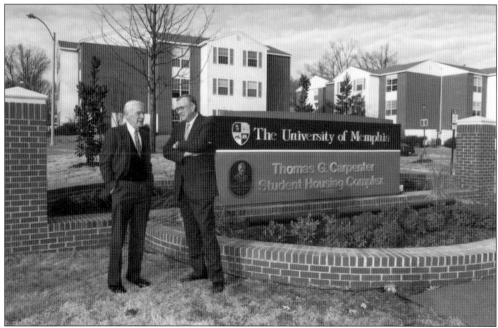

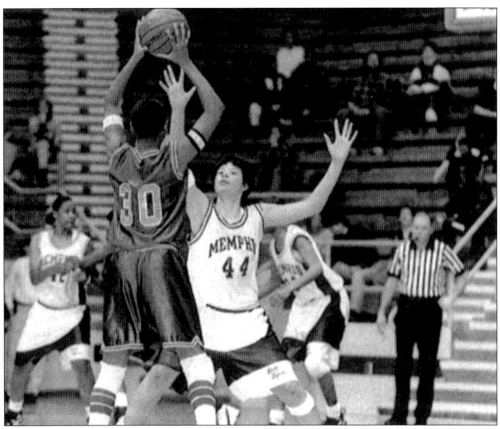

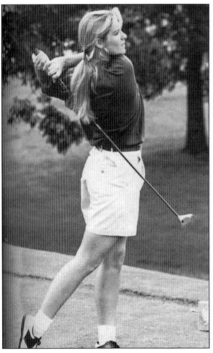

The Lady Tigers' loyal fan base regularly turns out to watch games in the Elma Roane Fieldhouse. Above, freshman Tamika Whitmore puts pressure on an opponent during a regular season game in 1996. Whitmore, who was recruited by and played under legendary coach Joye Lee-McNelis, was a C-USA all-conference first team member in 1997, 1998, and 1999. In the 1998 Women's National Invitation Tournament, Whitmore broke a 21-year-old record by scoring 45 points in a third-round win over Arkansas State. She went on to play in the Women's National Basketball Association for the New York Liberty, the Indiana Fever, and the Connecticut Sun.

Junior Heather Eschenberg watches her drive land on the fairway during a round of golf in 1996.

University of Memphis's men's rugby team is pictured in a game against Rhodes College in 1995.

Women's soccer joined the intercollegiate sports lineup in 1995.

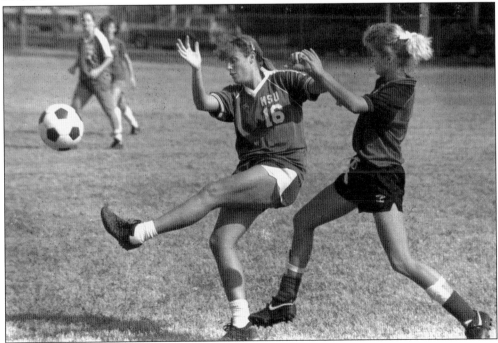

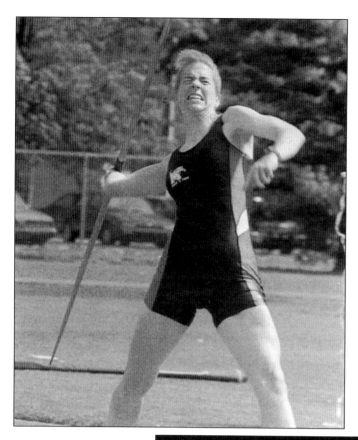

Senior Karen Cox led the women's track team in most events during her senior year. In this photograph, she competes in the javelin toss at a competition on the south campus.

Dancers perform in a recital of the University of Memphis' modern dance program. Established in 1995, the Department of Theatre and Dance presents performances in the Communication and Fine Arts Building's dance space. Fall and spring concerts include presentations of faculty, alumni, and guest artists, as well as student choreography.

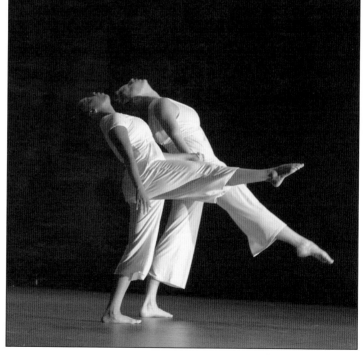

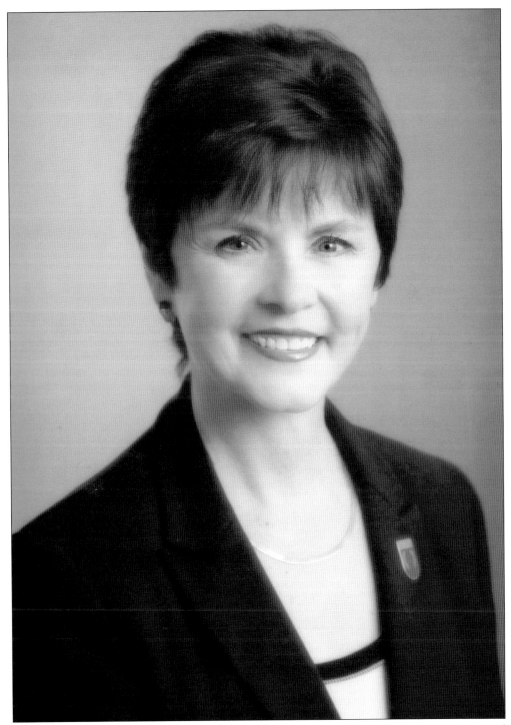

Shirley C. Raines, the 11th president from, 2001 to the present, received her master's and doctorate degrees in education from the University of Tennessee in Knoxville. Prior to her appointment at the university, Raines served as vice chancellor for Academic Services and dean of the College of Education at the University of Kentucky.

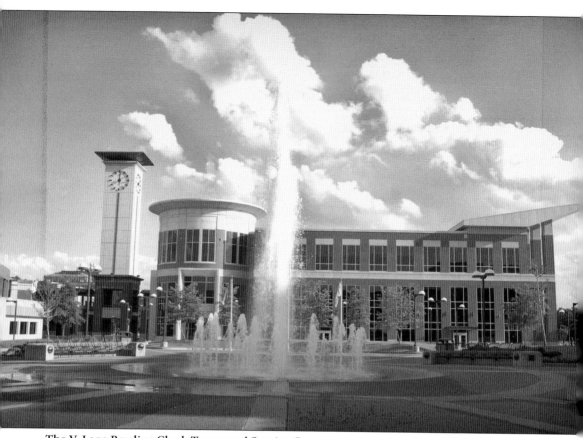

The V. Lane Rawlins Clock Tower and Service Court were completed in 2003 and dedicated as part of the University's 90th anniversary celebrations. The Service Court currently houses the university's bookstore, a coffee shop, the Tiger Banking Center, and Tiger Copy, Graphics, and Printing Services.

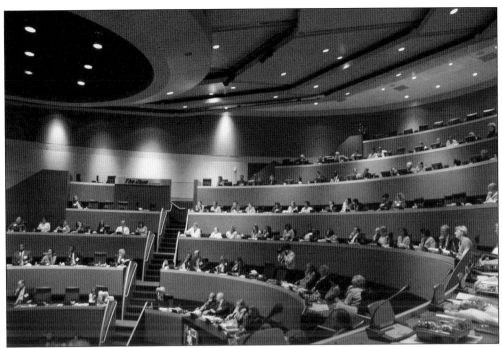

Launched in 2003, the FedEx Institute of Technology facilitates collaboration between the University of Memphis and industry, government, and community organizations. The institute is home to the University of Memphis Office of Technology Transfer and several interdisciplinary research centers. Pictured here, The Zone (the institute's main auditorium) provides state-of-the-art meeting space.

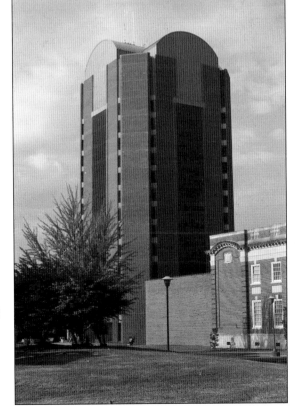

The tower of the old Brister Library underwent extensive renovations and was renamed for longtime Tennessee legislator John S. Wilder. Opened in 2003, Wilder Tower houses campus-wide student services, including admissions, financial aid, the registrar, and academic advising.

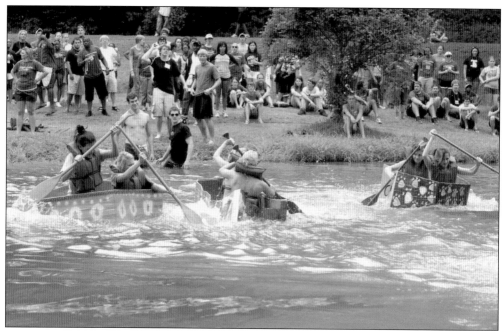

Incoming freshmen participate in an unconventional canoe race at Frosh Camp in the fall of 2007. Frosh Camp sessions, held in July and August, introduce freshmen to the University of Memphis. The camp takes place at Camp NaCoMe Conference Center, west of Memphis between Pleasantville and Centerville, Tennessee.

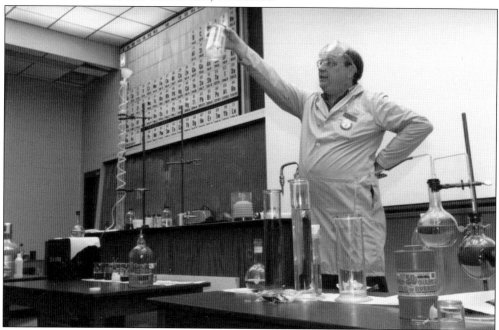

A chemistry professor explains a lab procedure in one of the science labs in J.M. Smith Hall. Smith Hall houses chemistry classes and offices, as well as the interdisciplinary Bioinformatics program, which combines mathematics and computer science with biology and medicine.

A student in the Lowenberg School of Nursing practices filling a syringe under the watchful eye of her professor. Established in 1967 as an independent department offering an associate's degree in nursing, the school of nursing now offers both BSN and MSN programs.

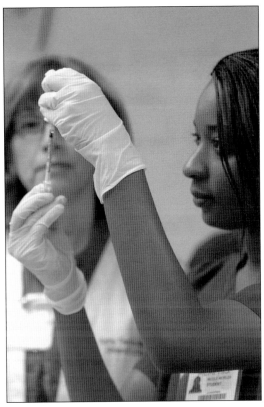

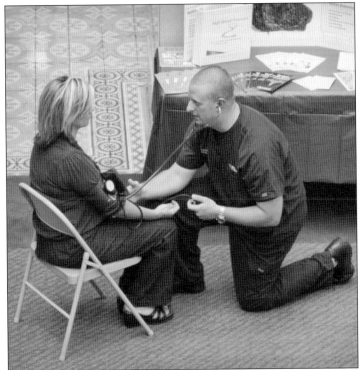

A nursing student checks blood pressure. Lowenberg students participate in quality programs shaped by the School of Nursing's core values of caring, diversity, integrity, and leadership.

Prof. Michael Hagge interacts with a student in his architecture class during an in-class demonstration. The Department of Architecture prepares students for the professional practice of architecture and interior design.

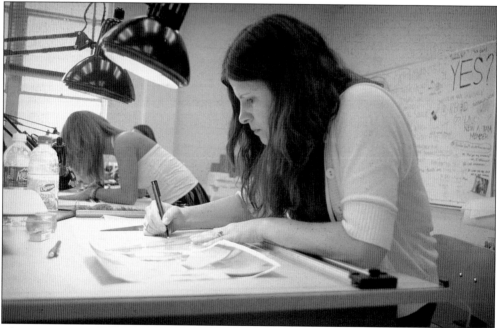

These architecture students work at drafting tables in the Architecture and Design House, one of the University of Memphis's Living Learning communities. Living Learning communities enable students with common academic interests to share on-campus living space, an arrangement which encourages the sharing of ideas and mirrors their future work experiences. Other Living Learning communities have included Freshmen First, Honors, Emerging Leaders, International House, Women in Engineering, and ROTC. The Living Learning communities are housed in the Living Learning Complex (LLC), which opened in the fall 2010 semester.

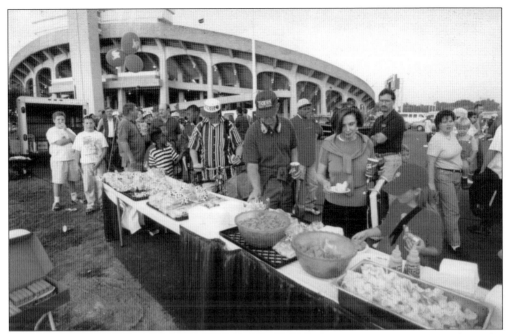

University alumni, young and old, attend a tailgate party at Liberty Bowl Stadium, where the Tigers have played their home games since 1965 (when it was known as Memorial Stadium).

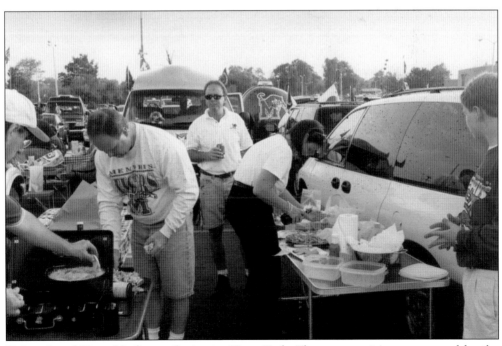

University of Memphis fans tailgate at a Tiger Trek. These group trips, sponsored by the alumni association, bring fans to the away football and basketball games.

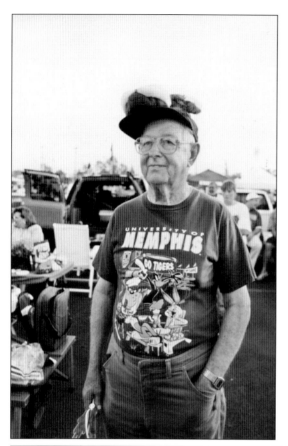

An impressive number of senior alumni participate in tailgating parties, Tiger Treks, and many other events for both men's and women's sports teams. The Half Century Club, the Young Alumni Committee, numerous regional clubs, and alumni groups from individual colleges, departments, and programs actively support the University of Memphis's scholastic and athletic efforts.

The Memphis Blues Queens serve as honorary hostesses for alumni at sporting events and during the Homecoming Parade. Below, Blues Queens grace the 2008 Homecoming Parade.

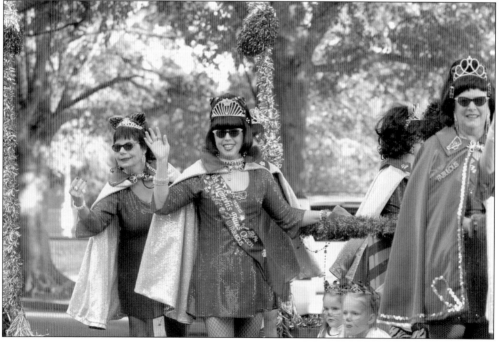

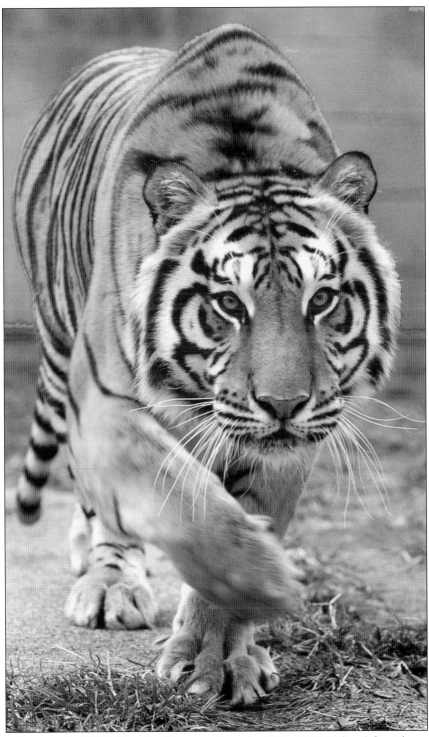
In this photograph, TOM II stalks his prey. Born in 1991, TOM II lived for 14 years in a custom-designed tiger house at a farm in Collierville. TOM III took up the mascot mantle after TOM II died in 2008. (Courtesy of the Commercial Appeal.)

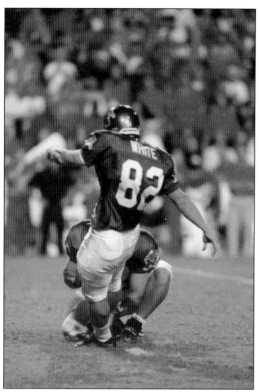

Tiger football draws crowds of students, alumni, and Memphis supporters to local and away games. In the photograph, No. 82 gets tackled during a game at the Liberty Bowl.

The University of Memphis's number-one true-blue booster, Pres. Shirley C. Raines, pumps up the crowd at an alumni association meeting. Dr. Raines appears at every home and many away games, cheering from the sidelines in her signature blue blazer.

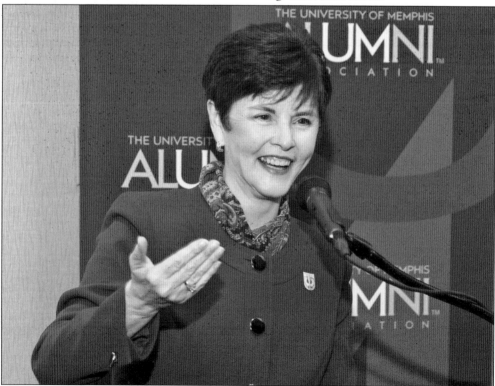

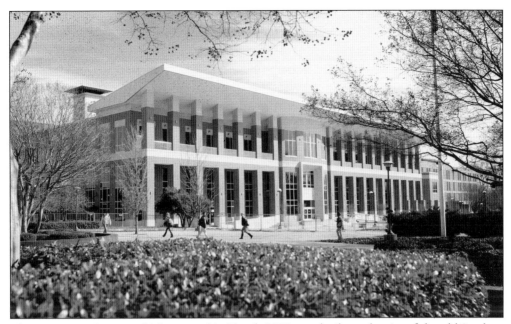

The University Center, which opened in March 2010, was built on the site of the old Student Center that was constructed in 1966. The new facility, the largest capital project in the school's history, was paid for with student fees, without any state funding.

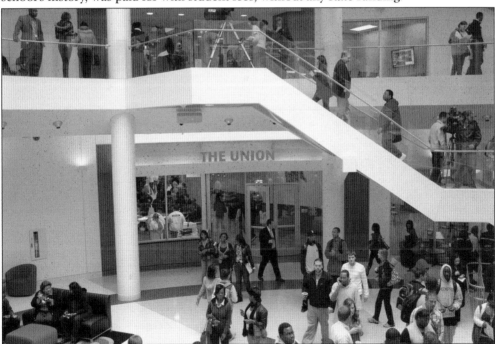

The 169,000-square-foot University Center features a food court, offices for student organizations, sororities and fraternities, Minority Affairs, the Dean of Students, Judicial and Ethical Programs, Student Government Association, student leadership, faculty senate, staff senate, the technology hub, and the ballroom. A central feature of the new university center is a three-story atrium.

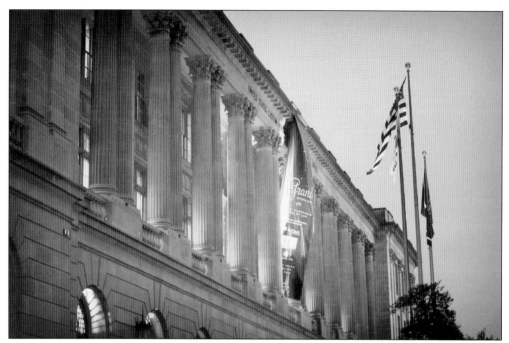

The Cecil C. Humphreys School of Law moved into new facilities on Front Street in downtown Memphis in January 2010. The university purchased the old Customs House, Federal Courthouse, and post office building, which was originally designed and constructed in the 1880s. In 2007, the building was purchased from the federal government for $5.3 million in privately donated funds. Over the next four years, the graceful building was completely renovated at a cost of $42 million, including a $2 million seismic retrofit. The new facility is located in the heart of the Memphis business and legal districts and affords law students better access to the city's legal community.

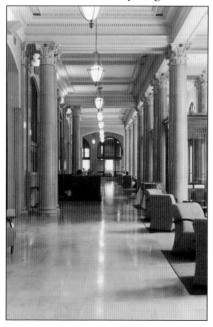

The lobby of the law school is part of the 1929 renovation and addition to this historic building. Renovators kept the original fixtures and details of the Italian Renaissance Revival building, including pink Tennessee marble wainscoting, cast-iron columns, curved period windows, and elaborately decorated brass doorknobs and hinges.

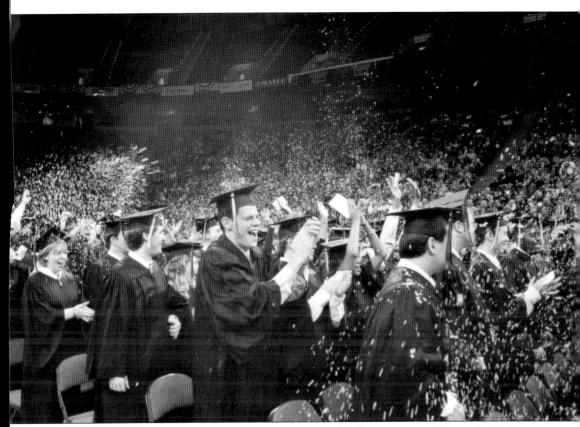

The university awards degrees in spring, summer, and fall ceremonies. Since the 1960s, ceremonies have been held at the Memphis Coliseum, the Memphis Pyramid, and, since the fall 2004 semester, at the FedEx Forum. With increasingly large graduating classes, the University of Memphis split the ceremonies at the fall and spring graduations into morning and afternoon events. In its first commencement in May 1913, West Tennessee Normal School awarded 44 degrees. In the spring 2011 ceremonies, the University of Memphis awarded 2,170 undergraduate, graduate, and professional degrees.

DISCOVER THOUSANDS OF LOCAL HISTORY BOOKS FEATURING MILLIONS OF VINTAGE IMAGES

Arcadia Publishing, the leading local history publisher in the United States, is committed to making history accessible and meaningful through publishing books that celebrate and preserve the heritage of America's people and places.

Find more books like this at
www.arcadiapublishing.com

Search for your hometown history, your old stomping grounds, and even your favorite sports team.

Consistent with our mission to preserve history on a local level, this book was printed in South Carolina on American-made paper and manufactured entirely in the United States. Products carrying the accredited Forest Stewardship Council (FSC) label are printed on 100 percent FSC-certified paper.